HOW TO DRAW MANGA

volume 6

Martial Arts & Combat Sports

Fight scenes are difficult, but fighting motions can be found in martial arts. This is because fighting is the starting point of martial arts.

Hitting and Kicking-Karate
Punching-Boxing
Grabbing, Throwing, and Choking-Judo
Hitting with Weapon-Kendo

This book contains the basic ideas needed to draw fights or battle scenes and the essence of how to apply them.

Please note that the purpose of this book is not to acknowledge or promote violence. It is a reference book designed for helping people draw more effective comics.

HOW TO DRAW MANGA Volume 6: Martial Arts & Combat Sports
by Hikaru Hayashi, Supervised by Kunichika Harada

Copyright © 2001 Hikaru Hayashi & Kunichika Harada
Copyright © 2001 Graphic-sha Publishing Co., Ltd.

First designed and published in 2001 by Graphic-sha Publishing Co., Ltd.
This English edition was published in 2002 by Graphic-sha Publishing Co., Ltd.
Sansou Kudan Bldg. 4th Floor
1-14-17 Kudan-kita, Chiyoda-ku, Tokyo 102-0073, Japan

Cover drawing: Kazuaki Morita
Drawing and production: Kunichika Harada, Yukihide Kariya, Mitsuo Takada, Chou Jiku Ajari
Scenario and composition: Hikaru Hayashi, Go Office
Title page design: Eiji Co., Ltd.
Photographs: Yuji Mori
Data collection incorporated by: Keiji Yasui
Japanese edition editor: Motofumi Nakanishi (Graphic-sha Publishing Co., Ltd.)

English title logo design: Hideyuki Amemura
English cover design: Shinichi Ishioka
English edition layout: Shinichi Ishioka
English translation: Língua fránca, Inc. (an3y-skmt@asahi-net.or.jp)
Foreign language edition project coordinator: Kumiko Sakamoto (Graphic-sha Publishing Co., Ltd.)

Distributor:
Japan Publications Trading Co., Ltd.
1-2-1 Sarugaku-cho, Chiyoda-ku, Tokyo, 101-0064
Telephone: +81(0)3-3292-3751 Fax: +81(0)3-3292-0410
E-mail: jpt@jptco.co.jp
URL: http://www.jptco.co.jp/

First printing: June 2002
Second printing: August 2002
Third printing: January 2003

ISBN 4-88996-082-1

Printed in China by Everbest printing Co., Ltd.

Introduction

Battles are by nature fighting, which is mankind's most basic means of waging warfare. Fights do not start at some predetermined place such as outdoors, on the street, or indoors. The well-known "street fight" is not a match in which the participants put on a uniform. To put it simply, a street fight is a physical altercation between participants wearing street clothes.

Comics, animations, and other works of fiction contain many fight and combat scenes. There are many fighting techniques that may be found in such works including everything from to vanquishing one's opponent without combat to martial arts. It is difficult to draw and film fight scenes, however, because the fights themselves are filled with unpredictable movements. Shots that can be turned into cool pictures, however, can be found in systematized "martial arts."

The starting point of martial arts is by nature fighting. Martial arts are bodily techniques and knowledge borne of the pursuit and research of fighting/warfare techniques. There are many martial arts types and variations, but the essence of martial arts is hitting and kicking, grabbing and throwing, and choking. Added to this is attacking with a weapon. In other words, judo, karate, boxing, and kendo are refined forms of street fighting. Not only are these common, popular pursuits learned at school and other places but they also possess pictorial beauty and cool movements. As such, they serve as an extremely useful reference when rendering "battle" scenes.

Kunichika Harada

Table of Contents

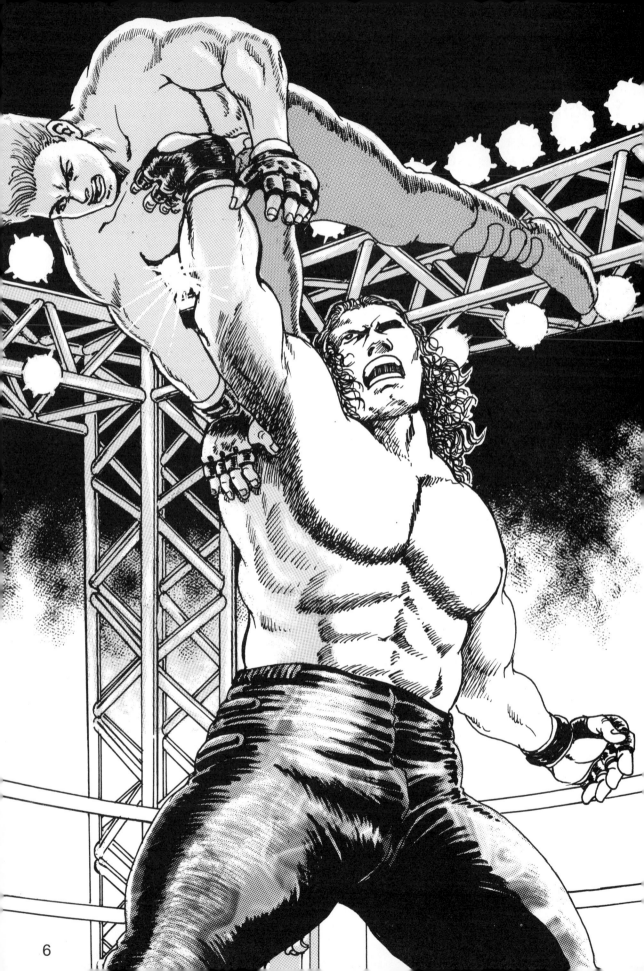

Impact & Power

1. Light

It creates shadows.
It gives weight and a sense of
reality to the flesh. It is light that
captures that moment.

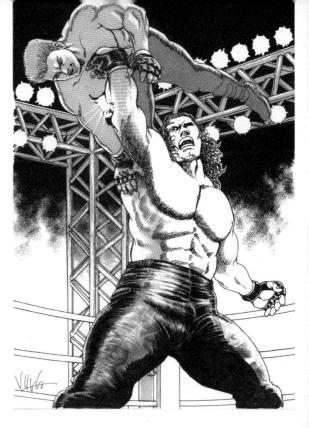

[Commentary]

The sense of reality of characters and the thickness and weight of the flesh are created by use of light and shade. Light illuminates all objects including characters and skin. Always think about where the light is coming from. There are many kinds of light: sunlight, indoor lights, streetlights, and spotlights. Use the type of light source that best brings to life the situation you want to depict. Of course, you can tailor the locale and composition of the picture to match the kind of light source you want to depict.

[Techniques]

Making shadows gray using tone is common. When you want to emphasize the flesh, add shadows to the flesh using diagonal lines. What makes light look most like light, however, is the black areas. It is black behind intense, pinpoint light sources like spotlights.

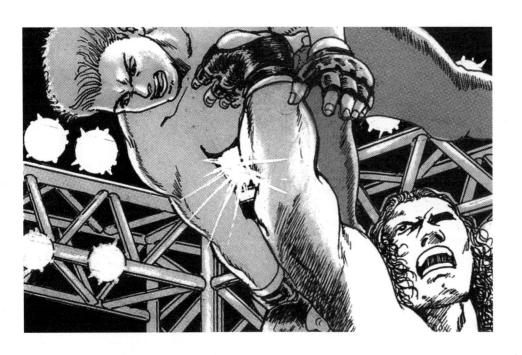

Impact & Power

2. Locale

In the background is an empty schoolhouse.
The protagonist appears with black
shadows in tow.
Who in the world is the girl waiting for him?

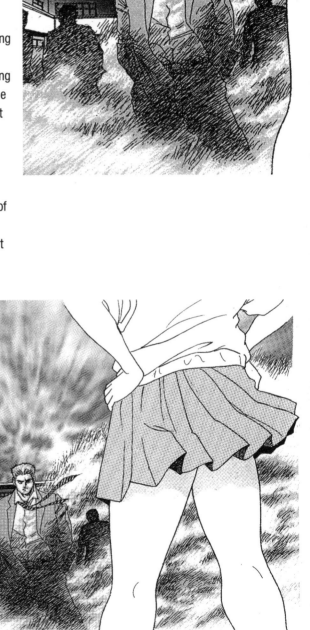

[Commentary]

The cloud of dust, the necktie streaming wildly, and the fluttering
skirt are used to render the wind. Since wind cannot be drawn
on a picture, this is how it is rendered. It has the effect of adding
movement and tension to a quiet scene. A schoolhouse or some
other building alone is enough to simply indicate a "place," but
the addition of wind creates time and drama, transforming an
image that "simply explains the situation" into a "locale."

[Techniques]

Using the same type of diagonal line to depict the lower body of
the protagonist and the silhouettes of the characters in the
background not only prevents the space from being divided but
also expresses the fact that they are all in the same cloud of
dust. On the contrary, making the legs of the girl in the
foreground white
enables you to impress
upon readers the fact
that she is "someone"
who differs from the
protagonist and the
silhouetted men.
Logically speaking,
this girl should also be
a part of the cloud of
dust, but it is
necessary in comics to
allow oneself not do it.

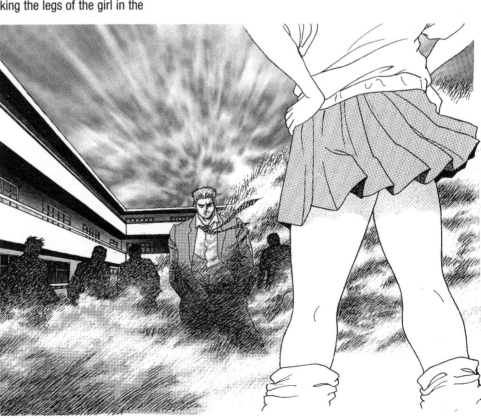

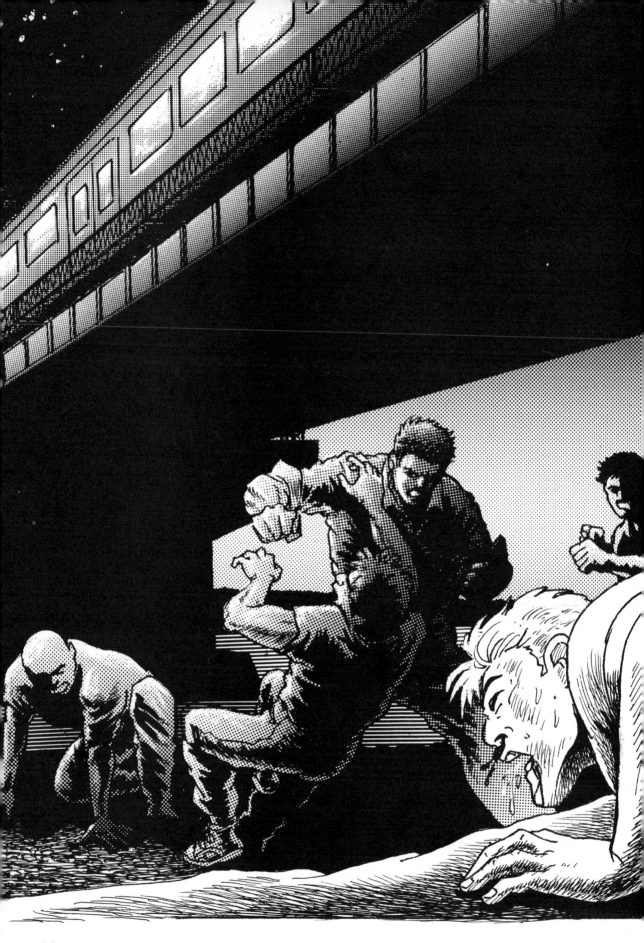

3. Sound

The roar of the train resonates.
Men are in a melee.
Breathing, groans, cries, and the sound
of bones breaking are drowned out.

[Commentary]
Unlike movies and animations, pictures in comics do not
move. Thought is given to the locale and situation in order
to give pictures a sense of motion and depth. In
particular, a battle can be thought of as a "light and
sound show." Various sounds foster pauses in a battle
and a sense of tension. It is important to keep in mind a
place that evokes "light and sound" when drawing the
place/space where a battle unfolds.

[Techniques]
For a melee scene with multiple opponents, draw an
approaching opponent, a downed opponent, an opponent
being punched and kicked, and an opponent who was
downed and is getting up again. These four types of
opponents are the minimum requirement for a melee
scene. You can depict an overwhelmingly strong
protagonist or a protagonist in a pinch by altering this
number.

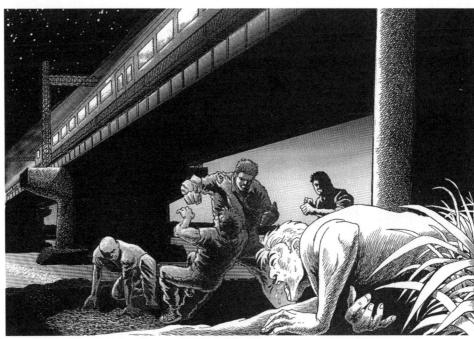

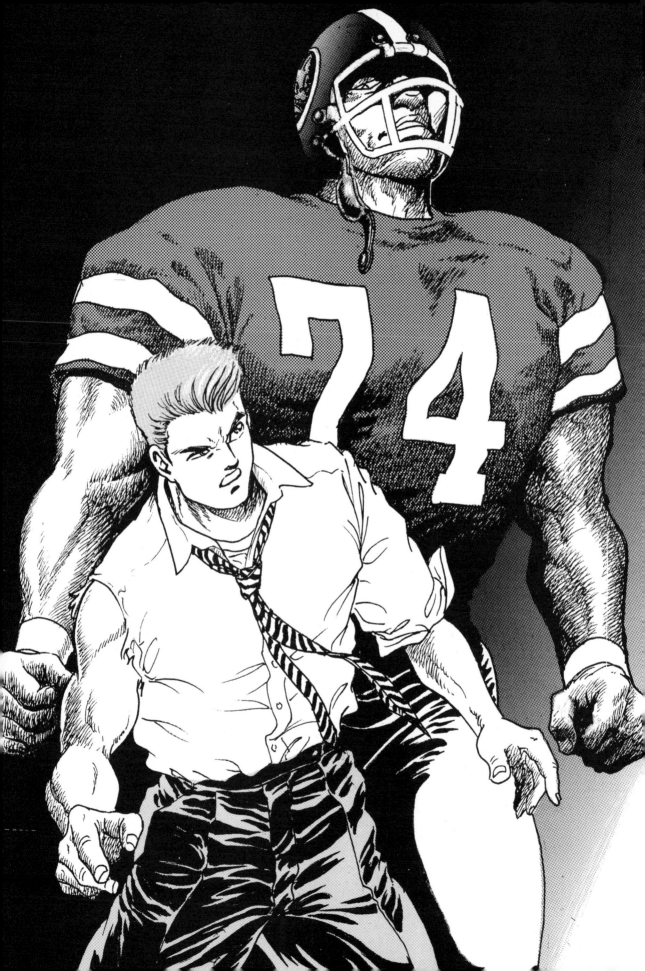

4. Characters

A mass of muscle stands towering
behind him.
The mouth of his expressionless
face is open.
What are his vacant eyes staring at?

[Commentary]

The "enemy" should basically be large and strong. Nobody
is going to take any delight in the protagonist beating a
feeble enemy. In order for a battle scene to work, the
cooler and stronger the protagonist is, the more you have
to create an enemy that the protagonist appears unable to
beat. In that sense, a battle is first and foremost a show.
Elements that draw readers in, keep them on the edge of
their seats, and generate anticipation are first found in two
characters having a "showdown." The locale and effects
surround the two battling characters.

[Techniques]

Introduce the enemy in parts. Do not reveal the entire enemy to readers all at once. The reason many villains
appear on the scene in silhouette is because the "mystery" surrounding the enemy generates fear and tension.
This holds true for scenes other than those involving martial arts. In addition, try not to expose the face of the
enemy right away by having the enemy wear a helmet or mask, regardless of whether or not it has any actual
significance. Helmets and other similar props are good for creating effects because part of the face will be
shaded.

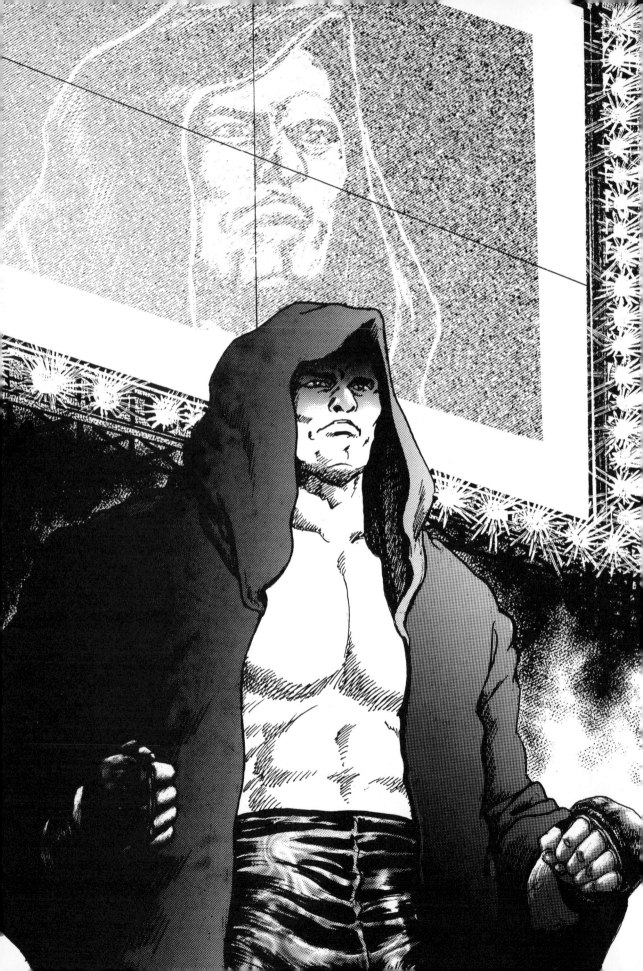

Impact & Power

5. Masks

A hood shrouds the face of a man with untold strength.
Pervasive fog contributes to the mysterious atmosphere.

[Commentary]

Use of hoods and masks is one way of conveying the impression of mystery. People are intrigued by things that are hidden. It heightens their curiosity. Consequently, hiding things is an indispensable technique.

[Techniques]

In a real martial arts bout, the fighters make their entrance surrounded by smoke and with illumination in the background. This is because it makes them look stronger and cooler. A low camera angle looking up slightly at the fighters will make their giant bodies look more imposing.

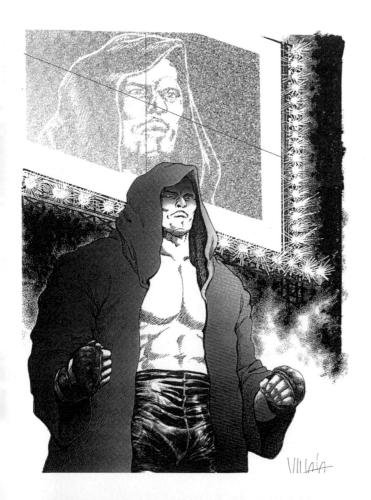

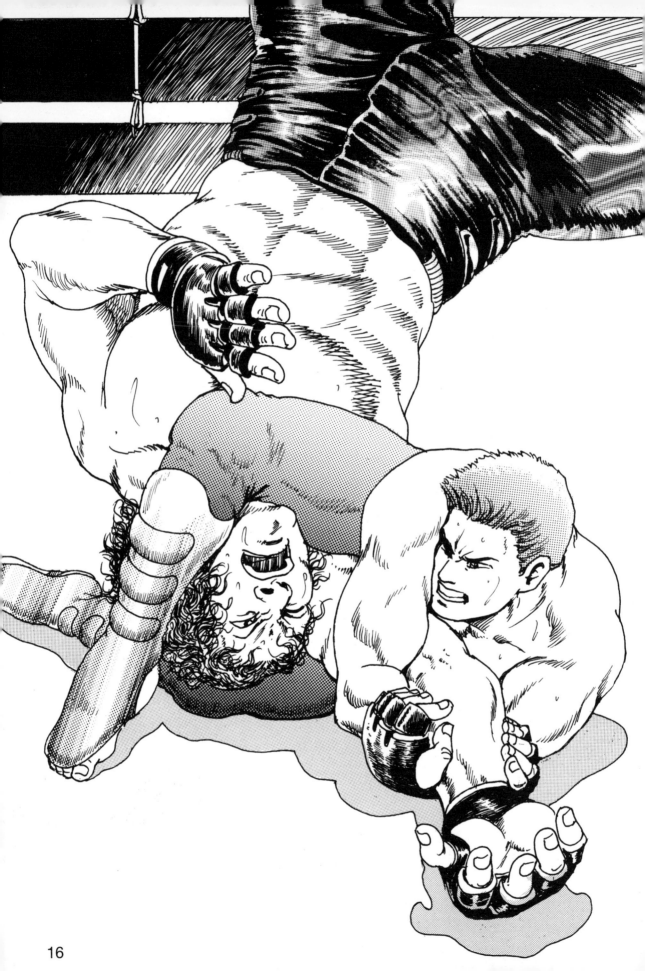

Impact & Power

6. Close-ups

Different parts of the flesh move at different speeds the instant an opponent is felled.
Though all the movement is fast, some parts move faster than others.

[Commentary]

Battle scenes can be either slow or fast paced depending on how the moment of the motion is captured. The speed of punches and kicks is usually rendered by shading arms and legs with diagonal lines. This is because an object moving at high speed is not visible. When stopping and drawing one part, on the other hand, using a close-up will allow you to carve out an "instant."

[Techniques]

Drawing shadows in the foreground on the floor under the part where the protagonist has the enemy in an arm lock, not on the floor below the falling body, freezes the action on the instant the enemy is defeated.

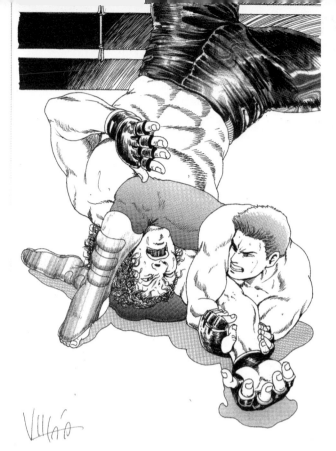

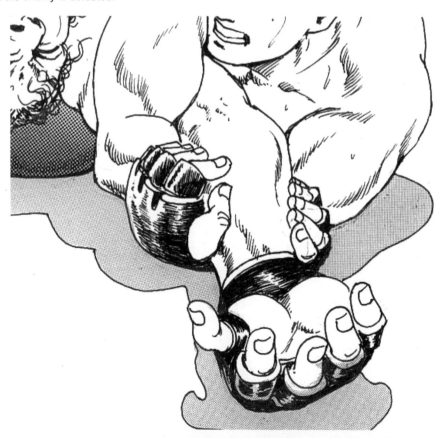

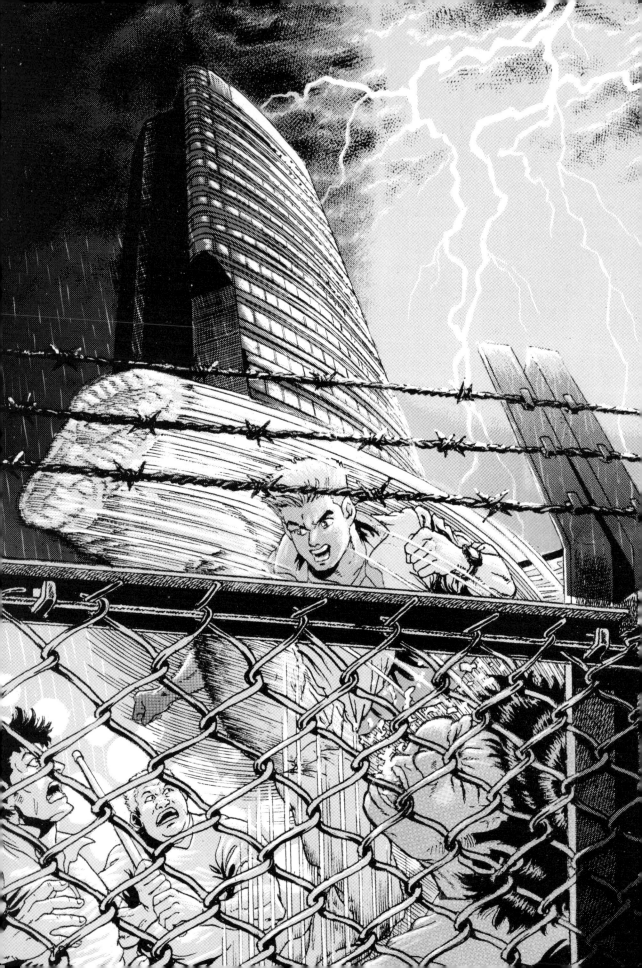

7. Free-For-Alls

There is a flash of lightening.
The fence shudders and the uproar of
the battle is drowned out by thunder.
A battle is a sound and light show.

[Commentary]

A battle is an instantaneous movie. It is a movie on one sheet of paper. It is not an exaggeration to say that the overall impression of a battle is determined by a single cut. Human beings are brought into relief by the sweat and pain of a fighting scene. The intense motion and breathing lying dormant within a picture are given life by harsh natural phenomena such as lightening and rain that evoke images of sound and air. The hard barbed wire and chain-link fence conjure up images of physical pain.

The large outdoor space is full of many elements that bring the picture and the reader together such as sprays of water, various sounds, pauses, and tension. These elements are especially required in a street fight that suddenly breaks out with the participants in their street clothes. The street battle is one of the most ideal situations for creating a cool battle scene.

[Techniques]

A flash of lightening is itself a source of light that is easy to understand. It is key to shading, which is indispensable to depicting the appearance of solidity and the sense of presence of buildings and characters. Making the edges of the fence shine emphasizes the cold peril of the metal and adds to the overall atmosphere of the image.

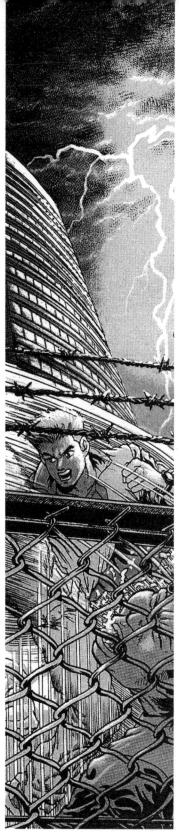

Judo

Make use of judo for scenes of "throwing" and "slamming to the ground."

The grappling begins with trying to break the balance of the opponent. The trick is to brilliantly and efficiently dodge the oncoming opponent. Then you want to outsmart the opponent and throw him to the ground. You can subdue the opponent with a lock if necessary. Let's learn how to draw "throws" and "locks" from judo, the king of self-defense.

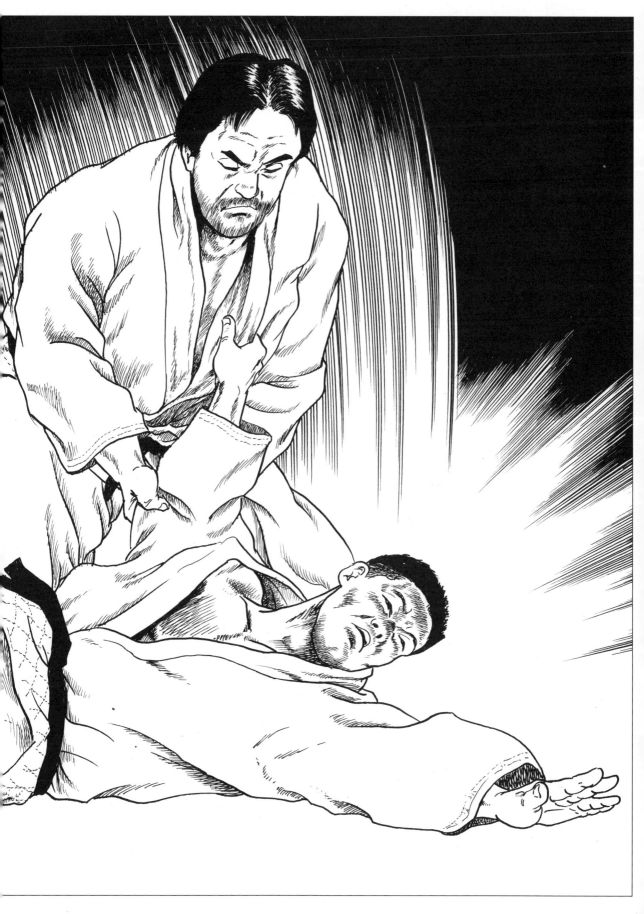

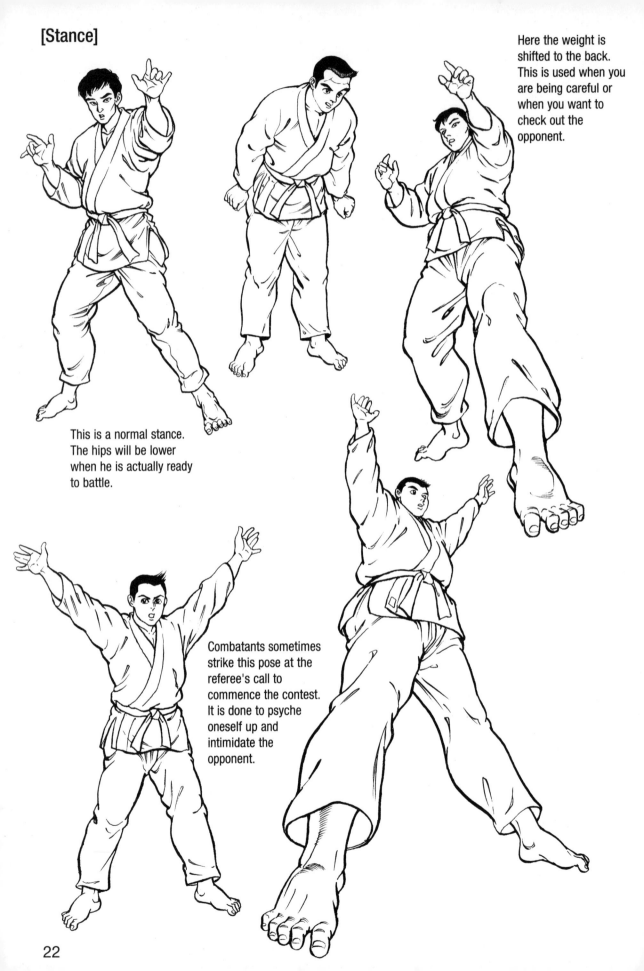

Here the weight is shifted to the back. This is used when you are being careful or when you want to check out the opponent.

This is a normal stance. The hips will be lower when he is actually ready to battle.

Combatants sometimes strike this pose at the referee's call to commence the contest. It is done to psyche oneself up and intimidate the opponent.

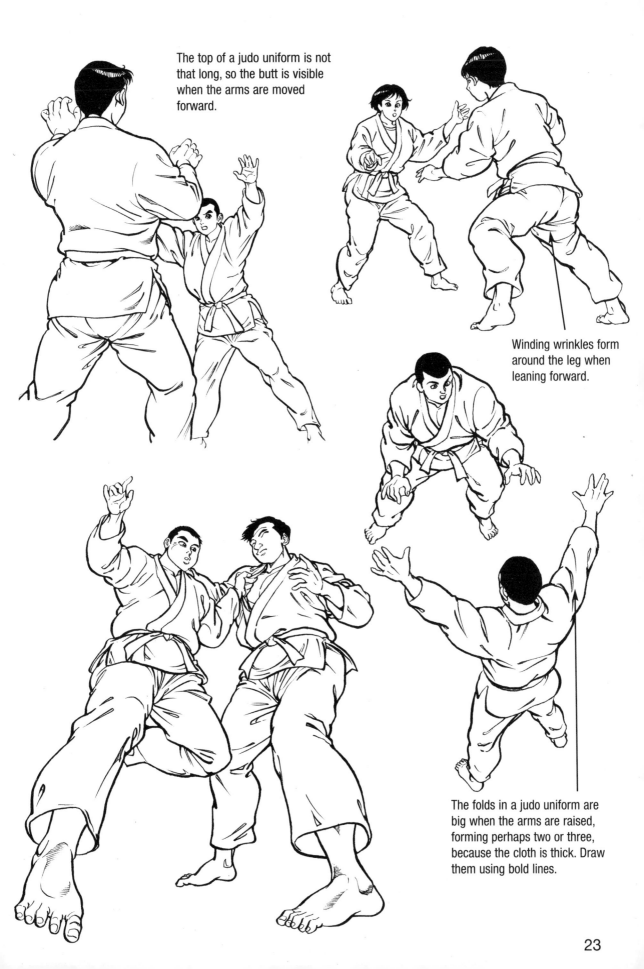

The top of a judo uniform is not that long, so the butt is visible when the arms are moved forward.

Winding wrinkles form around the leg when leaning forward.

The folds in a judo uniform are big when the arms are raised, forming perhaps two or three, because the cloth is thick. Draw them using bold lines.

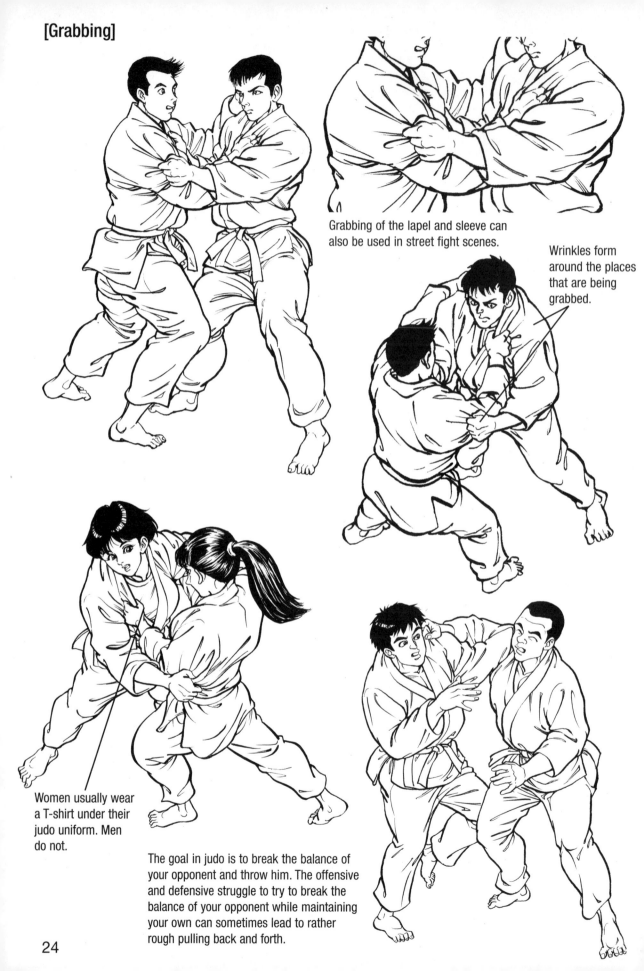

Grabbing of the lapel and sleeve can also be used in street fight scenes.

Wrinkles form around the places that are being grabbed.

Women usually wear a T-shirt under their judo uniform. Men do not.

The goal in judo is to break the balance of your opponent and throw him. The offensive and defensive struggle to try to break the balance of your opponent while maintaining your own can sometimes lead to rather rough pulling back and forth.

[Sweeping Hip Throws]

During a sweeping hip throw or inner thigh throw, you grab the inner lapel of the opponent with your right hand.

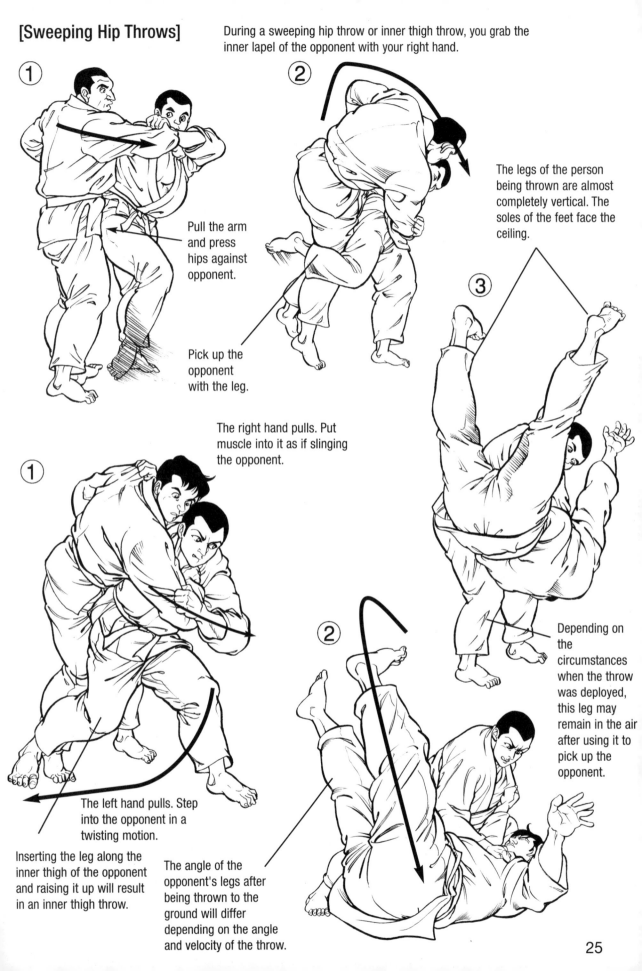

① Pull the arm and press hips against opponent.

Pick up the opponent with the leg.

② The legs of the person being thrown are almost completely vertical. The soles of the feet face the ceiling.

③ Depending on the circumstances when the throw was deployed, this leg may remain in the air after using it to pick up the opponent.

The right hand pulls. Put muscle into it as if slinging the opponent.

① The left hand pulls. Step into the opponent in a twisting motion.

Inserting the leg along the inner thigh of the opponent and raising it up will result in an inner thigh throw.

② The angle of the opponent's legs after being thrown to the ground will differ depending on the angle and velocity of the throw.

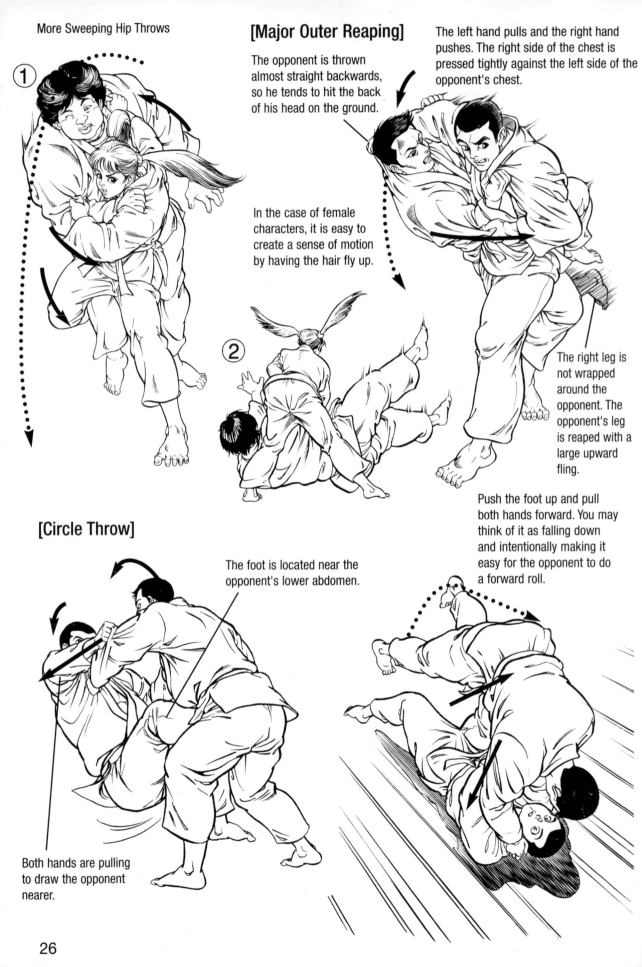

[Major Outer Reaping]

The opponent is thrown almost straight backwards, so he tends to hit the back of his head on the ground.

The left hand pulls and the right hand pushes. The right side of the chest is pressed tightly against the left side of the opponent's chest.

In the case of female characters, it is easy to create a sense of motion by having the hair fly up.

The right leg is not wrapped around the opponent. The opponent's leg is reaped with a large upward fling.

Push the foot up and pull both hands forward. You may think of it as falling down and intentionally making it easy for the opponent to do a forward roll.

① ②

[Circle Throw]

The foot is located near the opponent's lower abdomen.

Both hands are pulling to draw the opponent nearer.

[Body Drop Throw]

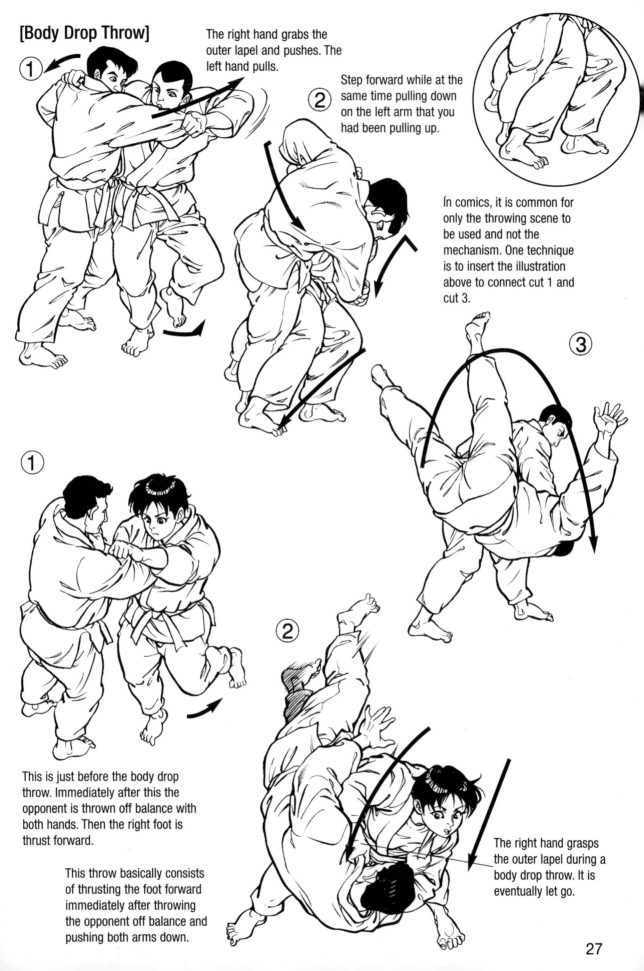

① The right hand grabs the outer lapel and pushes. The left hand pulls.

② Step forward while at the same time pulling down on the left arm that you had been pulling up.

In comics, it is common for only the throwing scene to be used and not the mechanism. One technique is to insert the illustration above to connect cut 1 and cut 3.

③

①

②

This is just before the body drop throw. Immediately after this the opponent is thrown off balance with both hands. Then the right foot is thrust forward.

This throw basically consists of thrusting the foot forward immediately after throwing the opponent off balance and pushing both arms down.

The right hand grasps the outer lapel during a body drop throw. It is eventually let go.

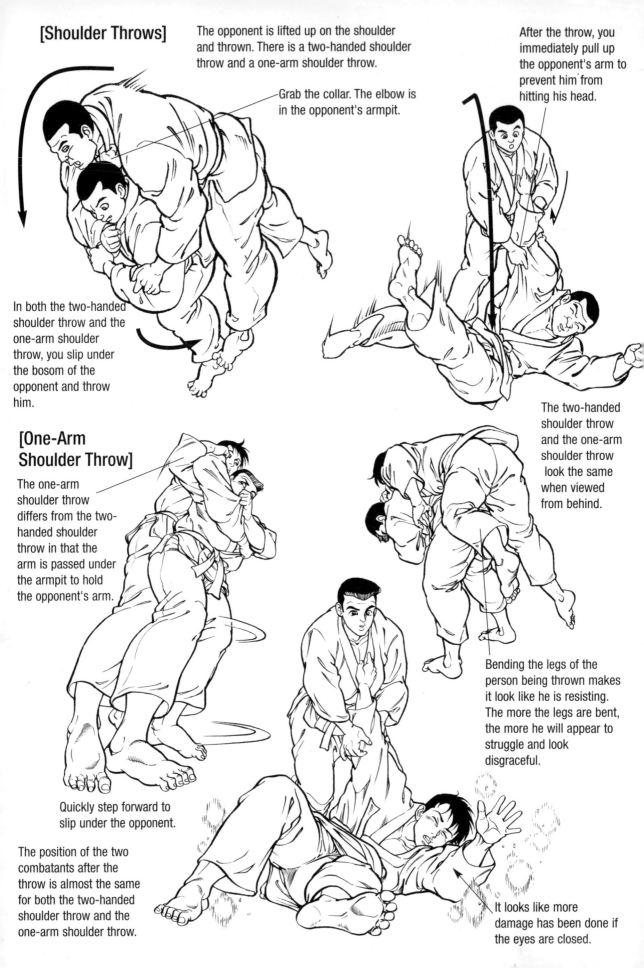

[Shoulder Throws]

The opponent is lifted up on the shoulder and thrown. There is a two-handed shoulder throw and a one-arm shoulder throw.

After the throw, you immediately pull up the opponent's arm to prevent him from hitting his head.

Grab the collar. The elbow is in the opponent's armpit.

In both the two-handed shoulder throw and the one-arm shoulder throw, you slip under the bosom of the opponent and throw him.

The two-handed shoulder throw and the one-arm shoulder throw look the same when viewed from behind.

[One-Arm Shoulder Throw]

The one-arm shoulder throw differs from the two-handed shoulder throw in that the arm is passed under the armpit to hold the opponent's arm.

Bending the legs of the person being thrown makes it look like he is resisting. The more the legs are bent, the more he will appear to struggle and look disgraceful.

Quickly step forward to slip under the opponent.

The position of the two combatants after the throw is almost the same for both the two-handed shoulder throw and the one-arm shoulder throw.

It looks like more damage has been done if the eyes are closed.

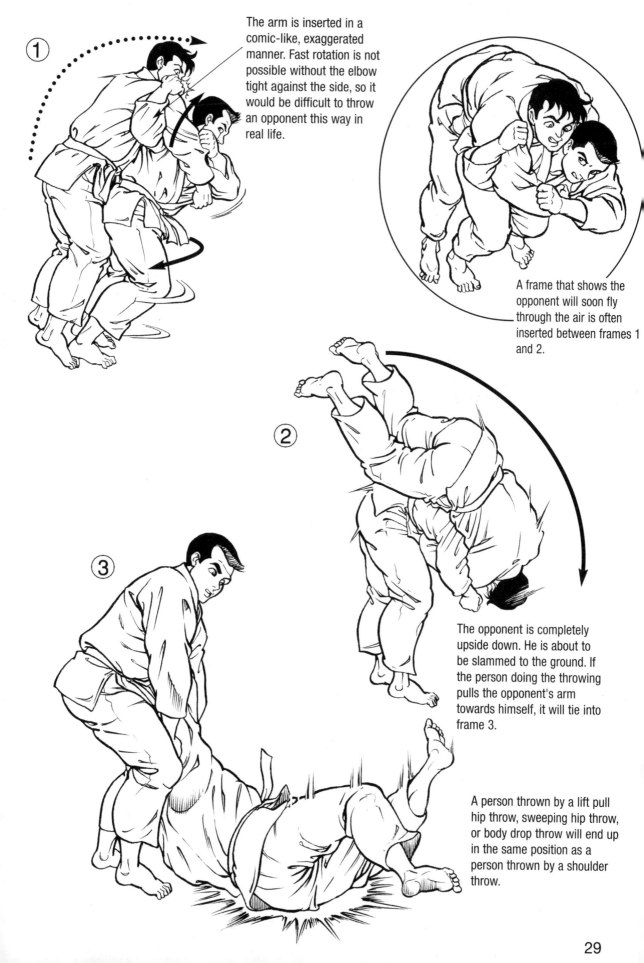

① The arm is inserted in a comic-like, exaggerated manner. Fast rotation is not possible without the elbow tight against the side, so it would be difficult to throw an opponent this way in real life.

A frame that shows the opponent will soon fly through the air is often inserted between frames 1 and 2.

② The opponent is completely upside down. He is about to be slammed to the ground. If the person doing the throwing pulls the opponent's arm towards himself, it will tie into frame 3.

③

A person thrown by a lift pull hip throw, sweeping hip throw, or body drop throw will end up in the same position as a person thrown by a shoulder throw.

[Scarf Hold]

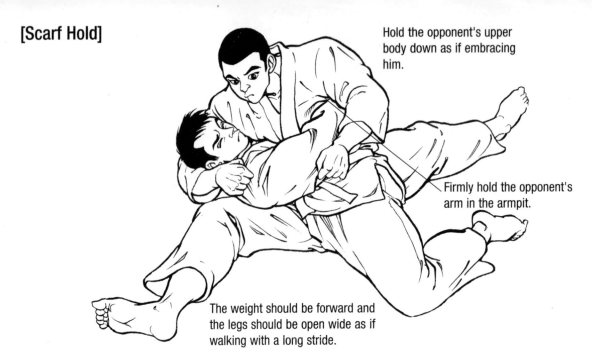

Hold the opponent's upper body down as if embracing him.

Firmly hold the opponent's arm in the armpit.

The weight should be forward and the legs should be open wide as if walking with a long stride.

[Side Four-Quarter Hold]

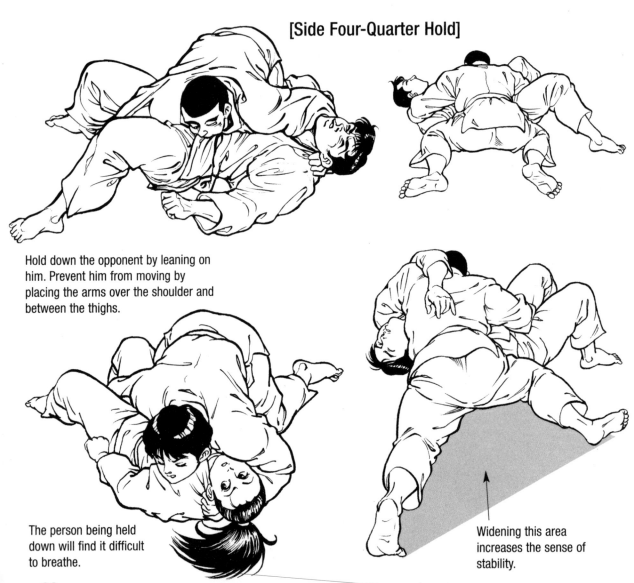

Hold down the opponent by leaning on him. Prevent him from moving by placing the arms over the shoulder and between the thighs.

The person being held down will find it difficult to breathe.

Widening this area increases the sense of stability.

[Upper Four-Quarter Hold]

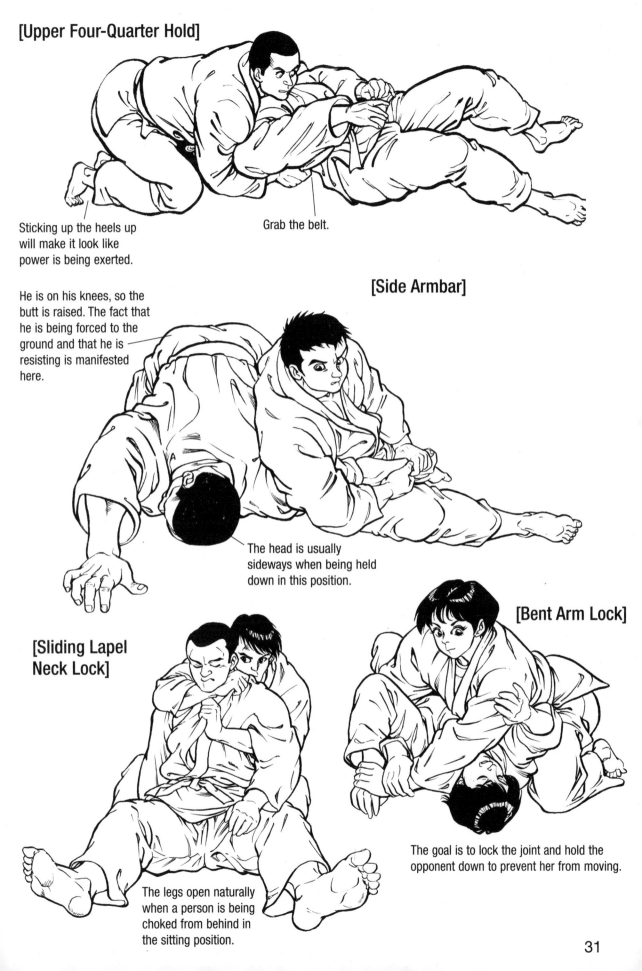

Sticking up the heels up will make it look like power is being exerted.

Grab the belt.

He is on his knees, so the butt is raised. The fact that he is being forced to the ground and that he is resisting is manifested here.

[Side Armbar]

The head is usually sideways when being held down in this position.

[Sliding Lapel Neck Lock]

The legs open naturally when a person is being choked from behind in the sitting position.

[Bent Arm Lock]

The goal is to lock the joint and hold the opponent down to prevent her from moving.

31

[Judo Uniform]

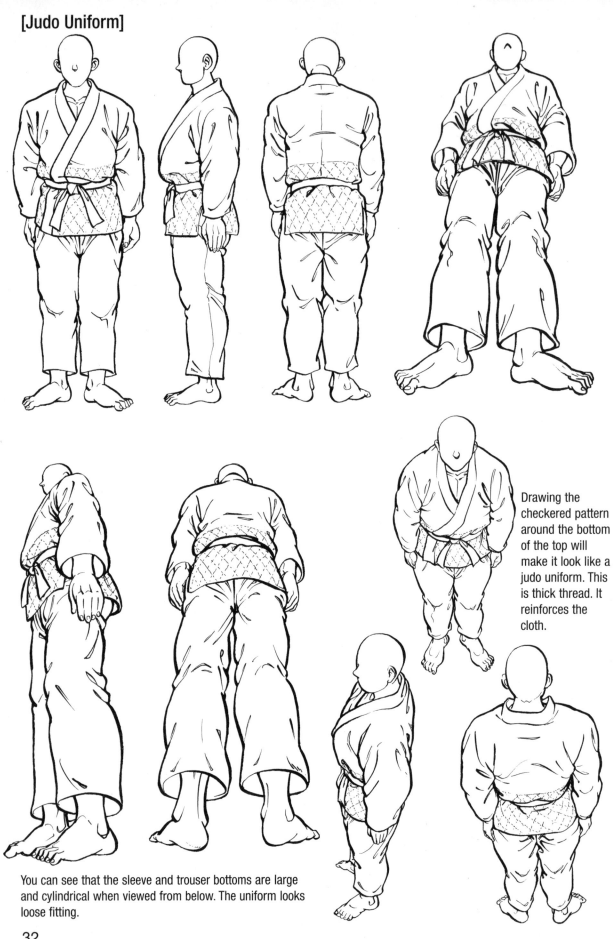

Drawing the checkered pattern around the bottom of the top will make it look like a judo uniform. This is thick thread. It reinforces the cloth.

You can see that the sleeve and trouser bottoms are large and cylindrical when viewed from below. The uniform looks loose fitting.

[Aikido]

Practice wear and ceremonial skirt. Also used in kung fu. It is similar to kendo practice wear, but only experts wear a ceremonial skirt. Judo- or karate-type practice wear is normally worn.

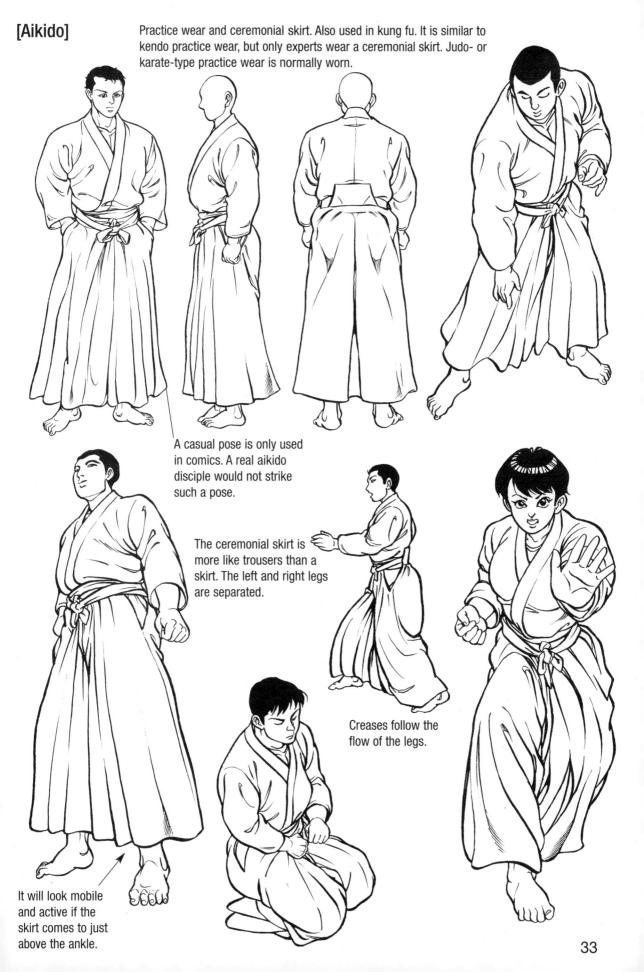

A casual pose is only used in comics. A real aikido disciple would not strike such a pose.

The ceremonial skirt is more like trousers than a skirt. The left and right legs are separated.

Creases follow the flow of the legs.

It will look mobile and active if the skirt comes to just above the ankle.

[Chinese Kung Fu]

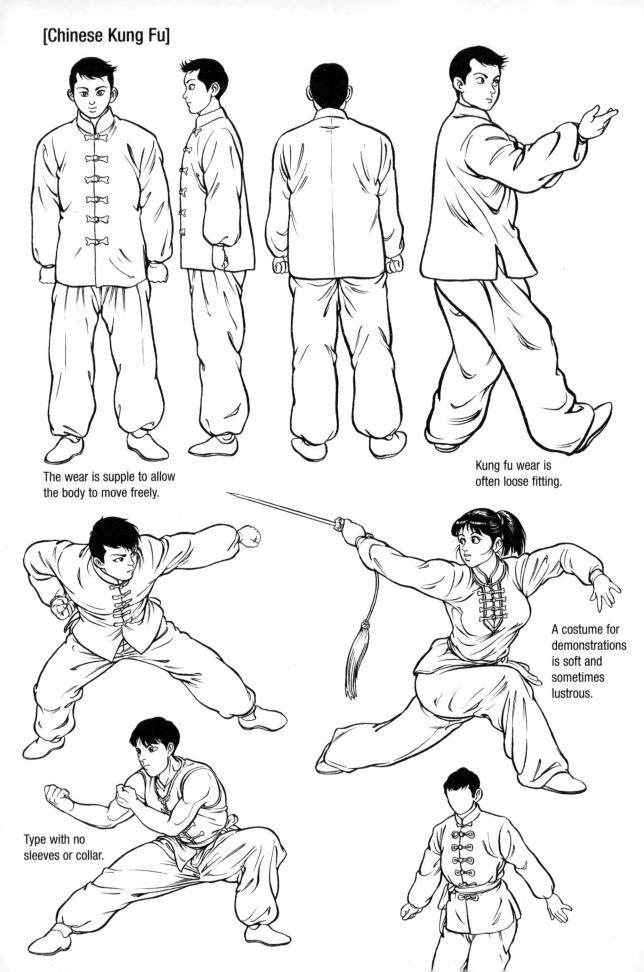

The wear is supple to allow
the body to move freely.

Kung fu wear is
often loose fitting.

A costume for
demonstrations
is soft and
sometimes
lustrous.

Type with no
sleeves or collar.

[Judo Contest Area]

The athletes wear a red or white belt over their normal belt for identification. The athlete wearing red is always on the right side as seen from the chief referee.

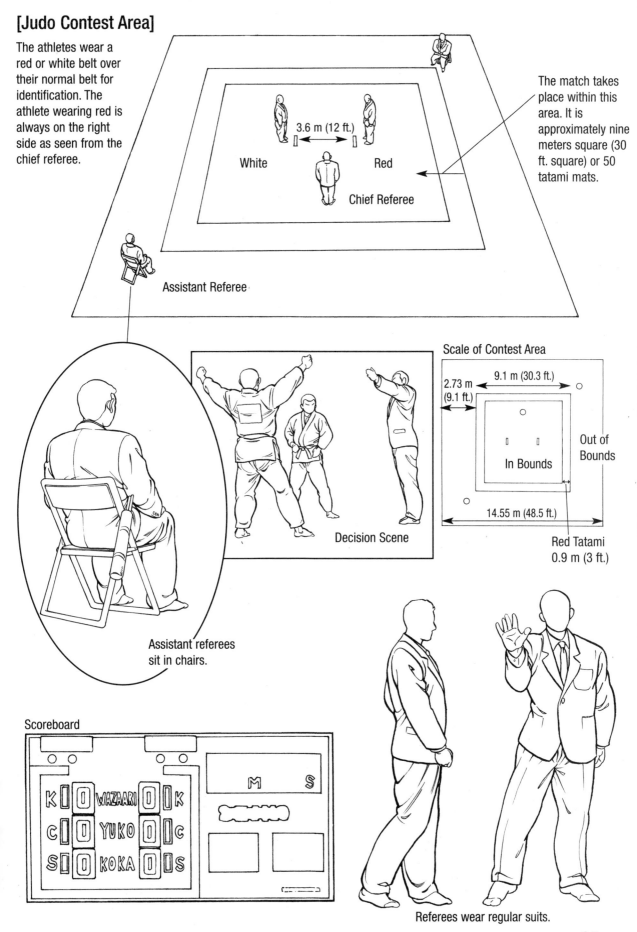

3.6 m (12 ft.)

White

Red

Chief Referee

The match takes place within this area. It is approximately nine meters square (30 ft. square) or 50 tatami mats.

Assistant Referee

Assistant referees sit in chairs.

Decision Scene

Scale of Contest Area

2.73 m (9.1 ft.)

9.1 m (30.3 ft.)

In Bounds

Out of Bounds

14.55 m (48.5 ft.)

Red Tatami 0.9 m (3 ft.)

Scoreboard

K WAZAARI K

C YUKO C

S KOKA S

M S

Referees wear regular suits.

Karate

Make use of karate for drawing scenes with "kicks" and "flying kicks."

Punching and kicking are the mainstays of battles. Sharp destructive power is more important than sheer physical strength. The essence of 360-degree action scenes can be learned from the sense of speed of karate.

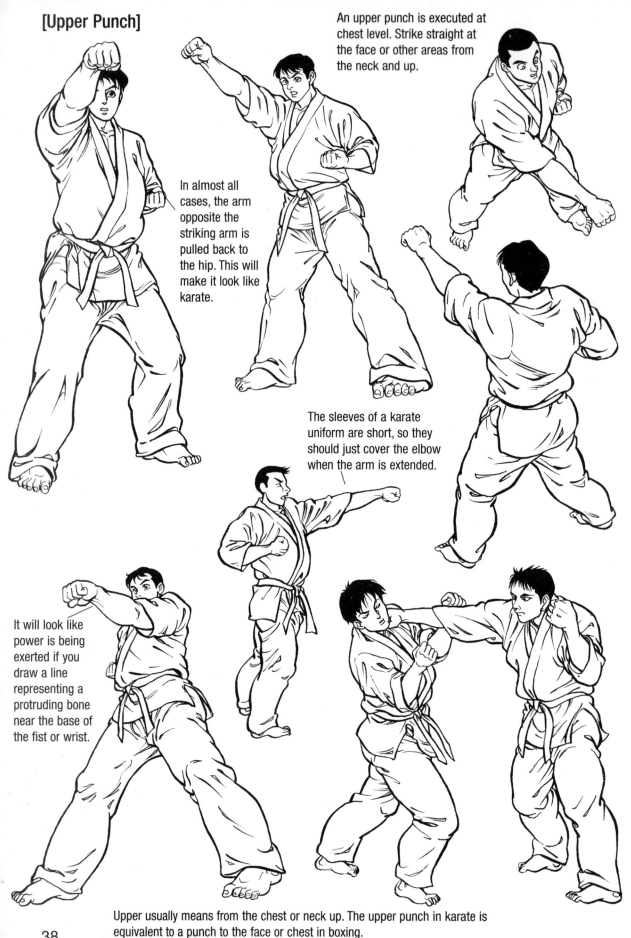

[Upper Punch]

An upper punch is executed at chest level. Strike straight at the face or other areas from the neck and up.

In almost all cases, the arm opposite the striking arm is pulled back to the hip. This will make it look like karate.

The sleeves of a karate uniform are short, so they should just cover the elbow when the arm is extended.

It will look like power is being exerted if you draw a line representing a protruding bone near the base of the fist or wrist.

Upper usually means from the chest or neck up. The upper punch in karate is equivalent to a punch to the face or chest in boxing.

[Middle Punch]

Strike the abdomen at the solar plexus.

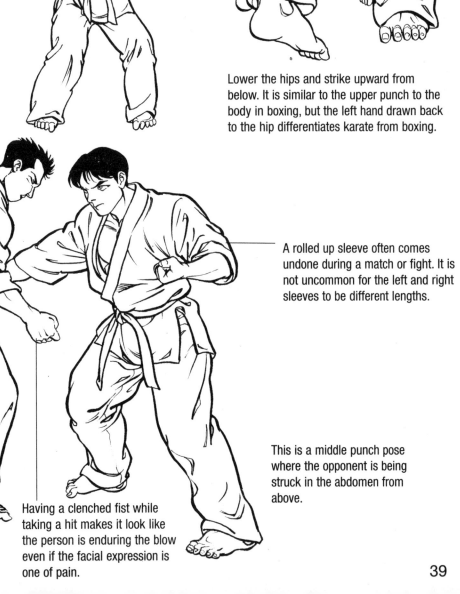

Lower the hips and strike upward from below. It is similar to the upper punch to the body in boxing, but the left hand drawn back to the hip differentiates karate from boxing.

A rolled up sleeve often comes undone during a match or fight. It is not uncommon for the left and right sleeves to be different lengths.

This is a middle punch pose where the opponent is being struck in the abdomen from above.

Having a clenched fist while taking a hit makes it look like the person is enduring the blow even if the facial expression is one of pain.

[Upper Kick]

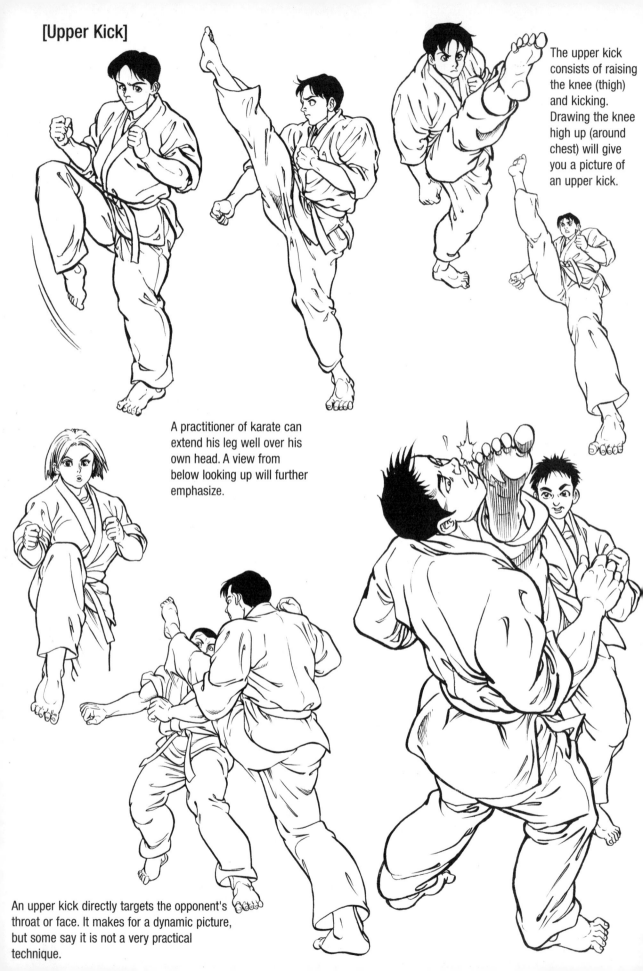

The upper kick consists of raising the knee (thigh) and kicking. Drawing the knee high up (around chest) will give you a picture of an upper kick.

A practitioner of karate can extend his leg well over his own head. A view from below looking up will further emphasize.

An upper kick directly targets the opponent's throat or face. It makes for a dynamic picture, but some say it is not a very practical technique.

[Middle Kick] Kick straight up to the solar plexus or abdomen.

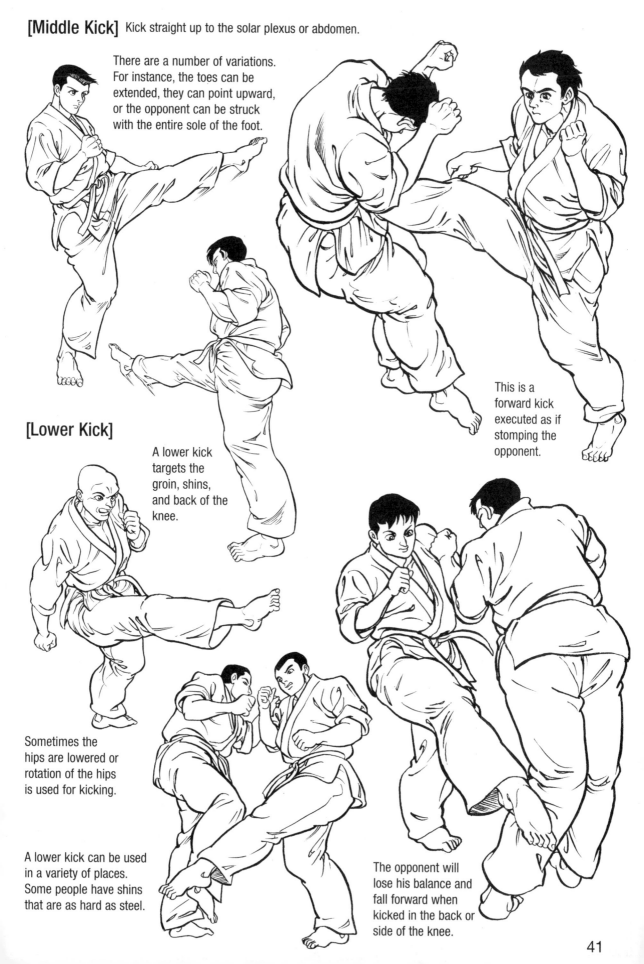

There are a number of variations. For instance, the toes can be extended, they can point upward, or the opponent can be struck with the entire sole of the foot.

This is a forward kick executed as if stomping the opponent.

[Lower Kick]

A lower kick targets the groin, shins, and back of the knee.

Sometimes the hips are lowered or rotation of the hips is used for kicking.

A lower kick can be used in a variety of places. Some people have shins that are as hard as steel.

The opponent will lose his balance and fall forward when kicked in the back or side of the knee.

[Roundhouse Kick]

This kick is almighty. It can strike upper, middle, and lower level targets.

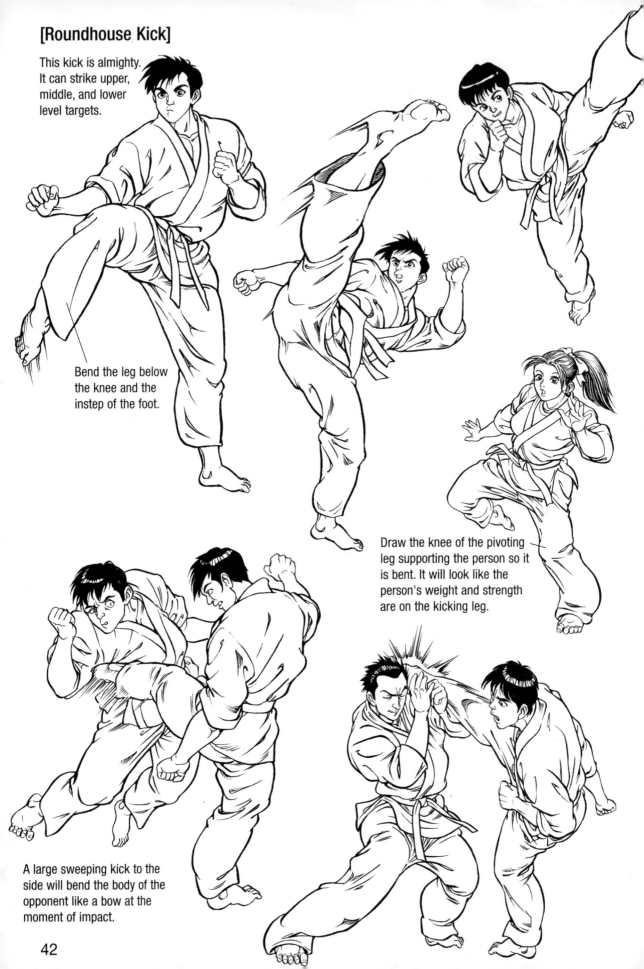

Bend the leg below the knee and the instep of the foot.

Draw the knee of the pivoting leg supporting the person so it is bent. It will look like the person's weight and strength are on the kicking leg.

A large sweeping kick to the side will bend the body of the opponent like a bow at the moment of impact.

[Flying Kick]

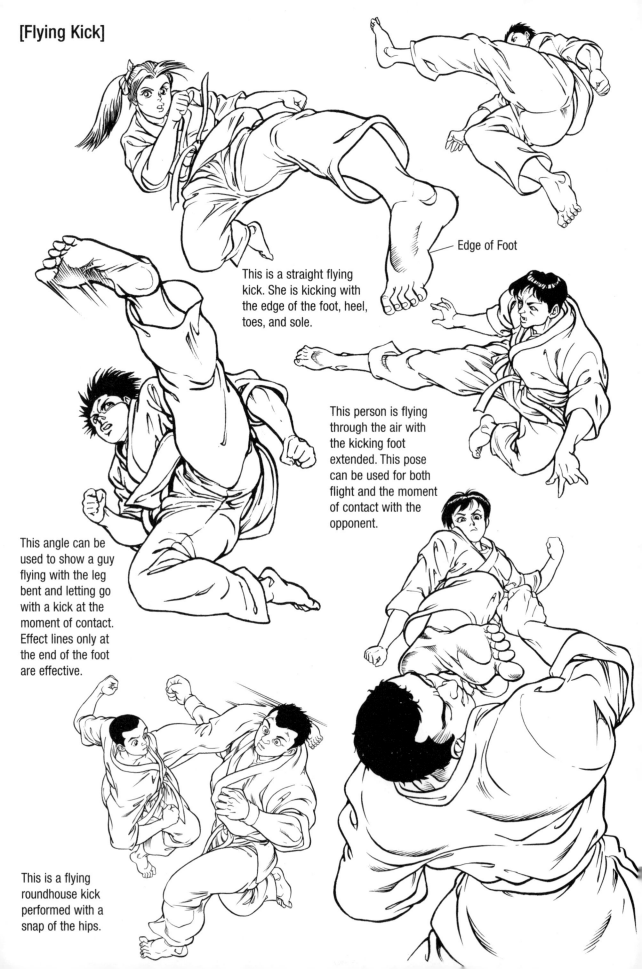

Edge of Foot

This is a straight flying kick. She is kicking with the edge of the foot, heel, toes, and sole.

This person is flying through the air with the kicking foot extended. This pose can be used for both flight and the moment of contact with the opponent.

This angle can be used to show a guy flying with the leg bent and letting go with a kick at the moment of contact. Effect lines only at the end of the foot are effective.

This is a flying roundhouse kick performed with a snap of the hips.

[Various Poses]

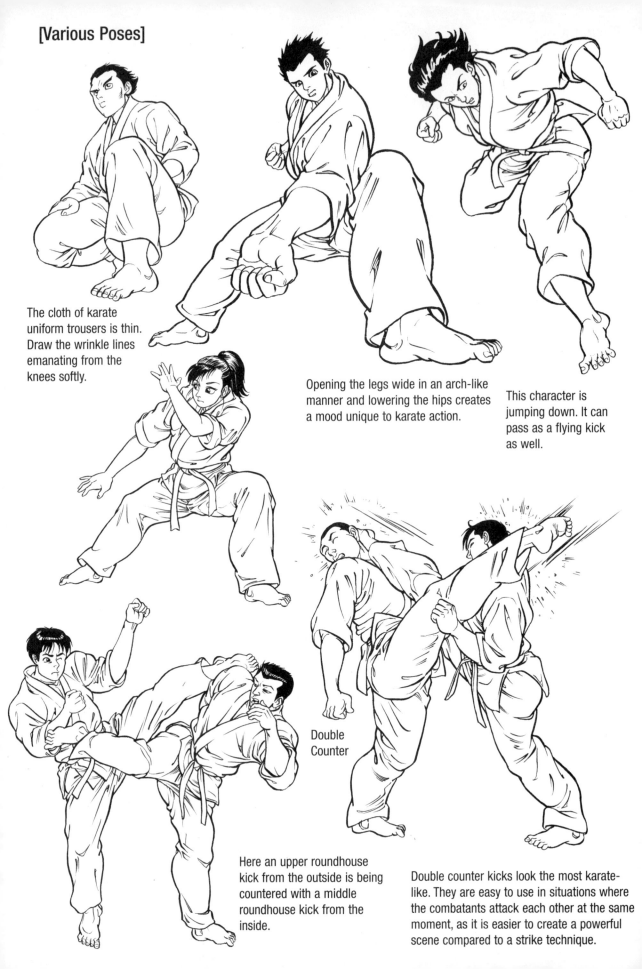

The cloth of karate uniform trousers is thin. Draw the wrinkle lines emanating from the knees softly.

Opening the legs wide in an arch-like manner and lowering the hips creates a mood unique to karate action.

This character is jumping down. It can pass as a flying kick as well.

Double Counter

Here an upper roundhouse kick from the outside is being countered with a middle roundhouse kick from the inside.

Double counter kicks look the most karate-like. They are easy to use in situations where the combatants attack each other at the same moment, as it is easier to create a powerful scene compared to a strike technique.

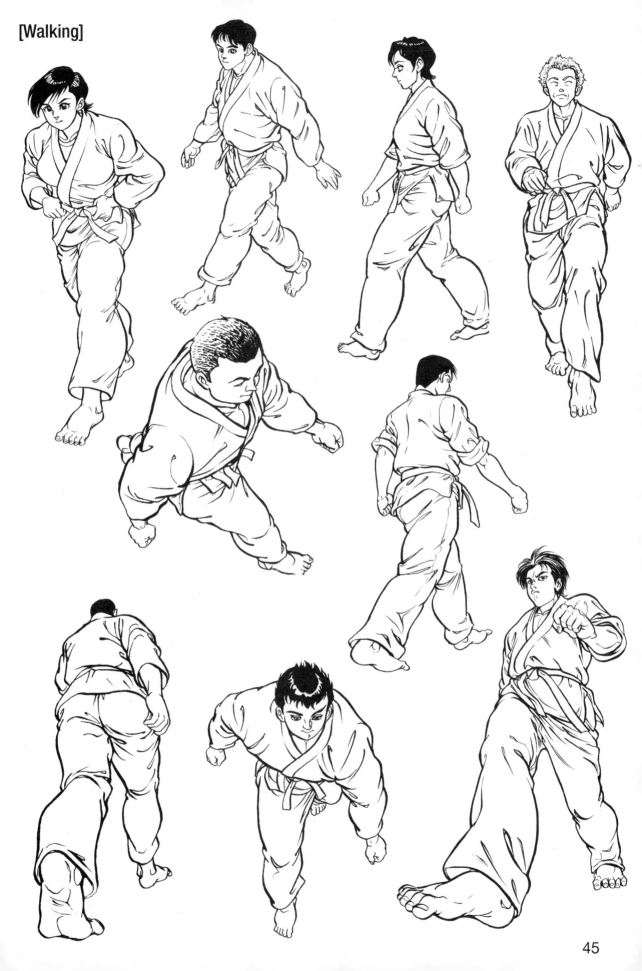

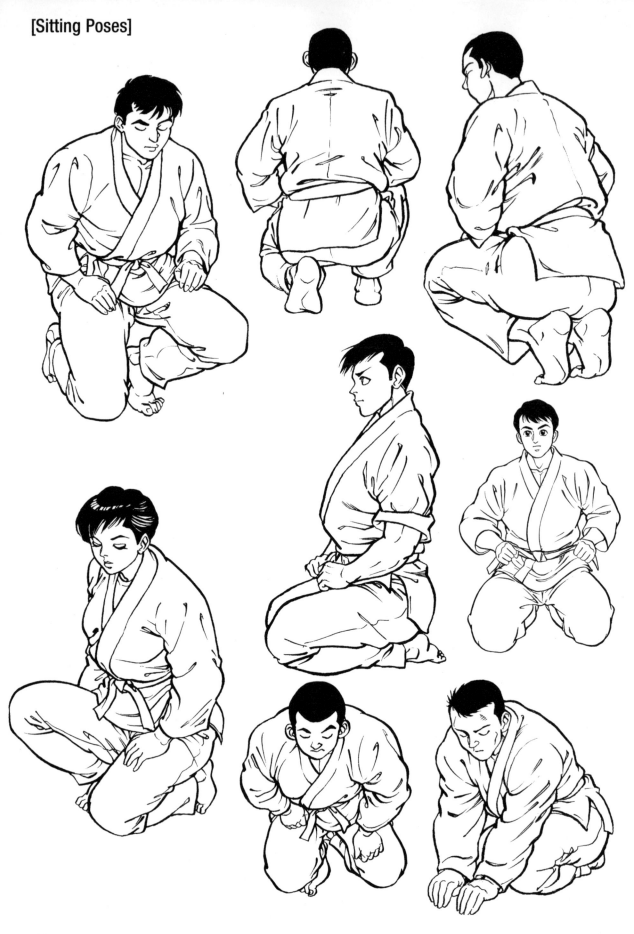

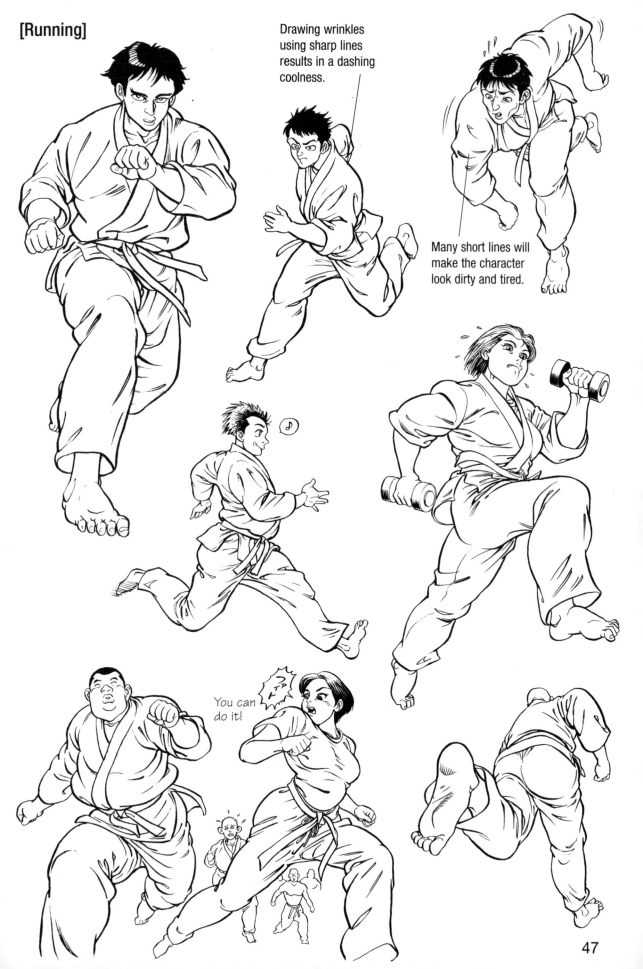

Drawing wrinkles using sharp lines results in a dashing coolness.

Many short lines will make the character look dirty and tired.

You can do it!

[Putting on Uniform] Karate and judo uniforms are pretty much the same.

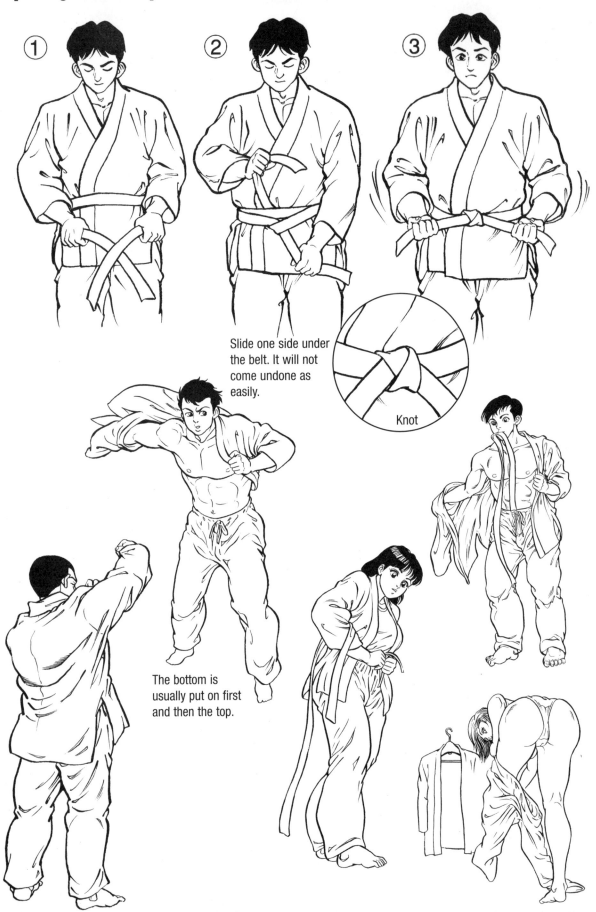

① ② ③

Slide one side under the belt. It will not come undone as easily.

Knot

The bottom is usually put on first and then the top.

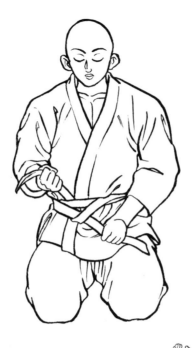
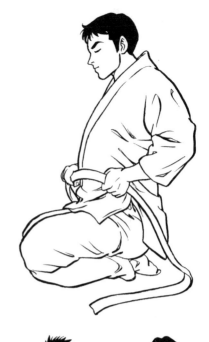

[Karate Uniform Variations]

Rolled-Up Sleeve Type

Sleeveless Type

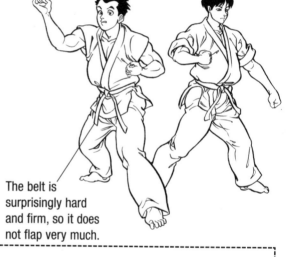

The belt is surprisingly hard and firm, so it does not flap very much.

[Differences Between Judo and Karate Uniforms-How to Distinguish the Two]

Judo and karate uniforms are basically the same. Distinguish the two by the difference in the cloth when drawing.

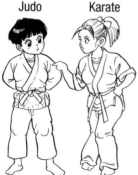

Judo Karate

Drawing check stitching around the bottom of the top makes it look like a judo uniform. It represents the thickness of the cloth.

The difference in the cloth can be expressed by the wrinkles and the bulging.

Judo Uniform

The sleeves are long.

The belt is tied a little above the waist.

Karate

The sleeves are shorter than a three-quarter sleeve.

The belt is a little lower.

The belt is on the long side.

The trousers are on the long side. The heels may be hidden.

[Common Mistakes & Remedies]

This picture of clearly drawn Japanese roof tiles or ice blocks being broken has power. A martial arts practitioner might find a glaring error in a picture that looks fine at a glance or is okay for a normal comic. Breaking of materials using karate strikes is an important technique that is usually performed by a practitioner with a black belt. Let's take a look at common errors that people make when drawing this in a comic.

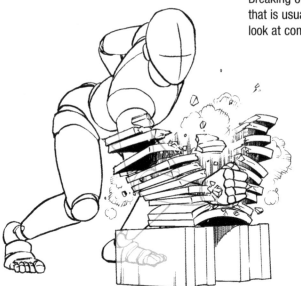

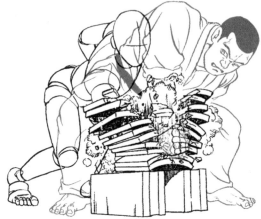

This would be no problem for a character with insane, comic-like strength, but in real life the person would be closer to the roof tiles. In addition, when the legs are facing in this direction, only a straight thrust punch from directly above will generate the necessary force. When the character is breaking the material with a karate chop or the forearm, the picture may be more convincing if the knees point outward and the strike is made with the entire weight of the character.

The character is quite close to the roof tiles. The character is in the middle of breaking the tiles and there is one left. He will not be able to break the final tile if he does not have enough arm left. Consequently, a straight thrust punch will be more convincing.

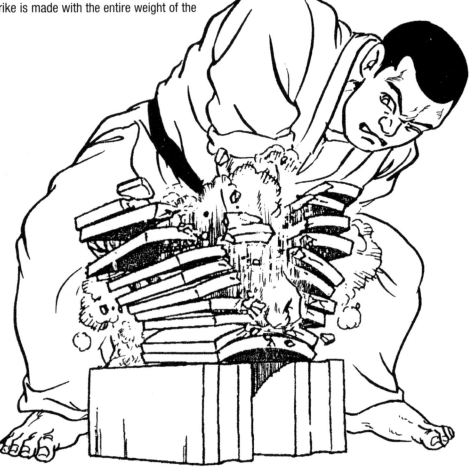

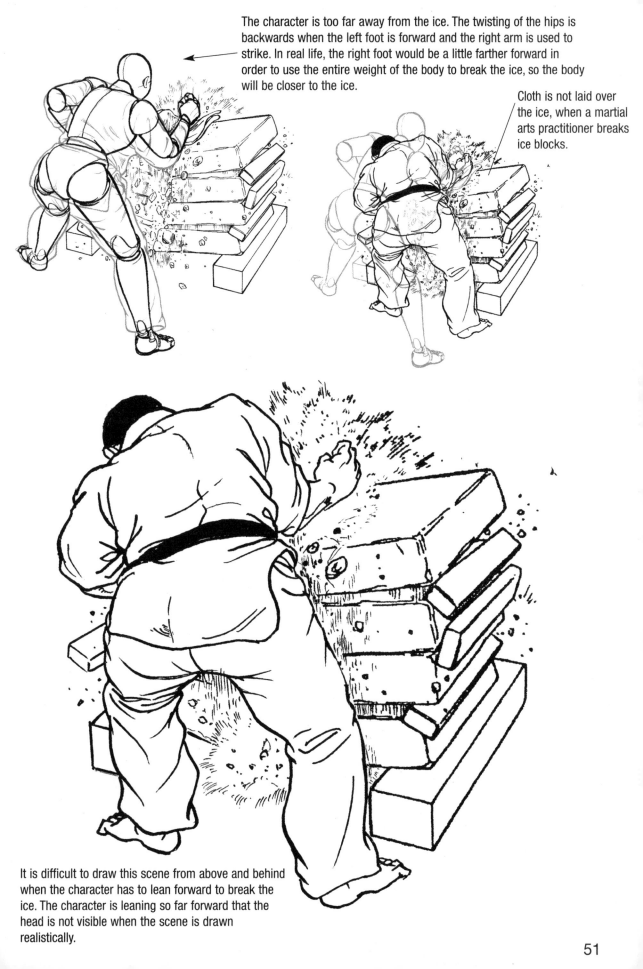

The character is too far away from the ice. The twisting of the hips is backwards when the left foot is forward and the right arm is used to strike. In real life, the right foot would be a little farther forward in order to use the entire weight of the body to break the ice, so the body will be closer to the ice.

Cloth is not laid over the ice, when a martial arts practitioner breaks ice blocks.

It is difficult to draw this scene from above and behind when the character has to lean forward to break the ice. The character is leaning so far forward that the head is not visible when the scene is drawn realistically.

Kendo

Make use of kendo for scenes of "hitting with a stick," "people sparring with sticks," and "actions with swords and daggers."

Hitting someone with a club or branch. Beat, cut down, and stab. Kendo is one of the highest forms of battles involving weapons. The essence of movement with a weapon (sword) can be found here.

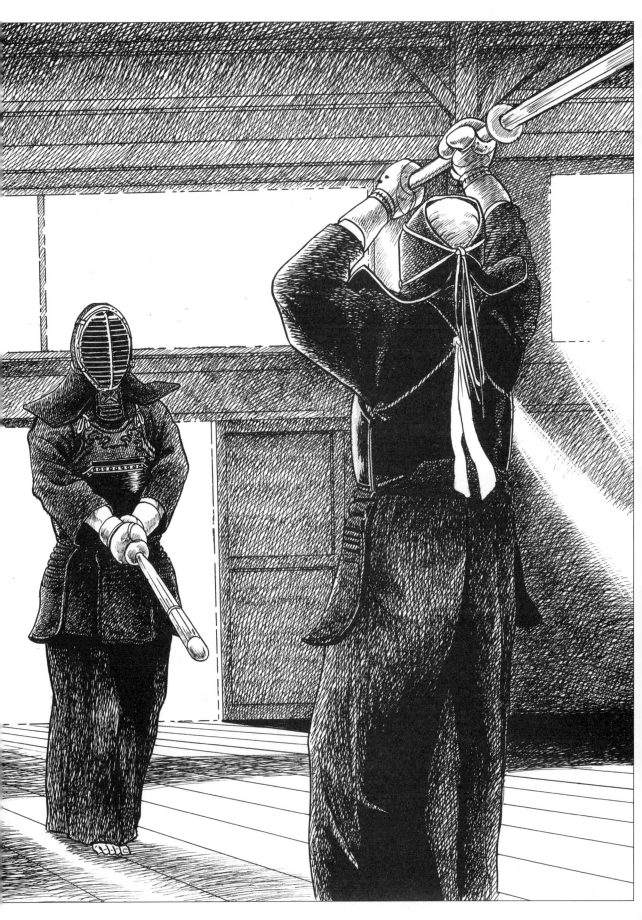

[Stance (Upper Stance)]

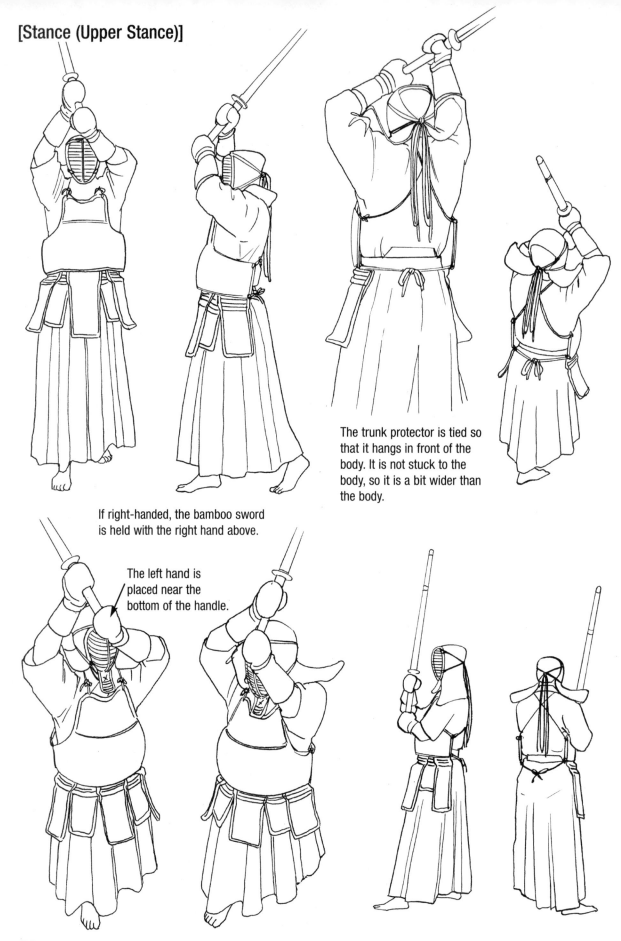

The trunk protector is tied so that it hangs in front of the body. It is not stuck to the body, so it is a bit wider than the body.

If right-handed, the bamboo sword is held with the right hand above.

The left hand is placed near the bottom of the handle.

[Facing Each Other (Face-Off)]

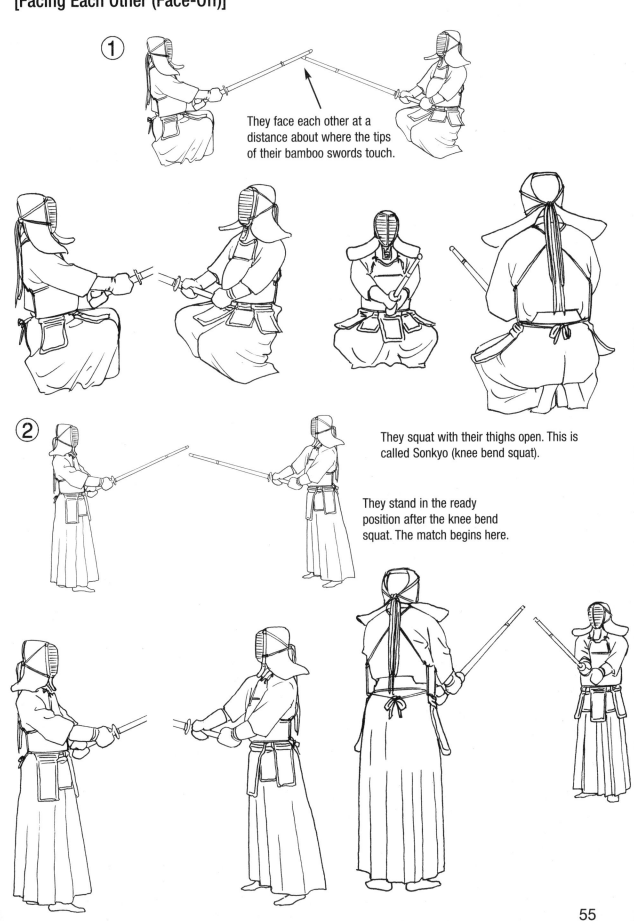

① They face each other at a distance about where the tips of their bamboo swords touch.

② They squat with their thighs open. This is called Sonkyo (knee bend squat).

They stand in the ready position after the knee bend squat. The match begins here.

[Fundamental Techniques]

Strike to Glove

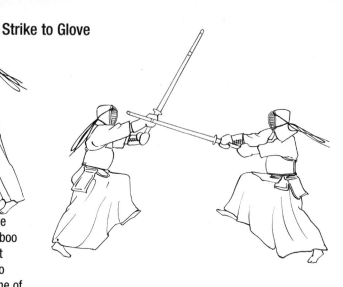

This is a strike to the hand area. It is often a preemptive strike used when the opponent tries to strike. The bamboo sword may be knocked out of your hands if you are not experienced. Kote (strike to glove) is shouted in order to focus as much energy and power as possible at the time of the strike.

Thrust to Throat Guard

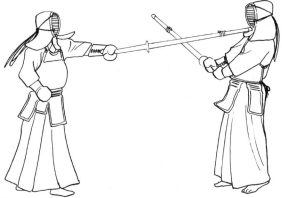

The throat area of the opponent is poked. This technique is extremely dangerous, so much so that it is often prohibited. It is sometimes executed with one hand when the opponent leaps forward and sometimes the throat is targeted with an aggressive thrust.

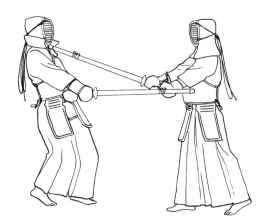

The shout used is tsuki. The last sounds of shouts are usually lengthened.

Strike to Face Mask

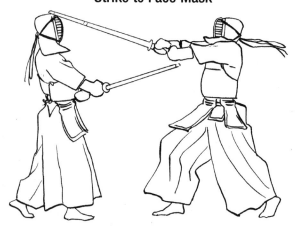

The top of the forehead is struck from directly above. The forehead will be split open if no protective gear is worn and a wooden sword is used. It is sometimes executed with a cut from the upper left or right or it is unleashed when passing by the opponent.

Strike to Trunk Protector

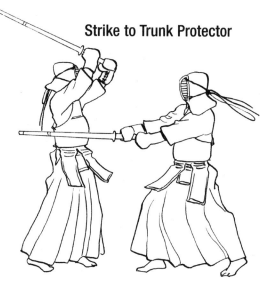

This is a strike to the chest area. It is more like hitting than the cutting down from the side you see in a samurai sword fight. The trajectory could be a straight line or diagonal. In comics, the trajectory itself is sometimes not drawn. ✧ is drawn instead.

[Free Practice/Hitting Each Other]

Here the character on the left is attacking as his opponent comes forward.

This is a successful strike to the facemask. This picture captures the instant he began to strike.

The attacking character is stepping firmly forward. In contrast, the knee of this character is locked and his upper body is drawn somewhat straight up. It looks like he is vulnerable and caught off guard as he is unable to keep up with the speed of the attacker.

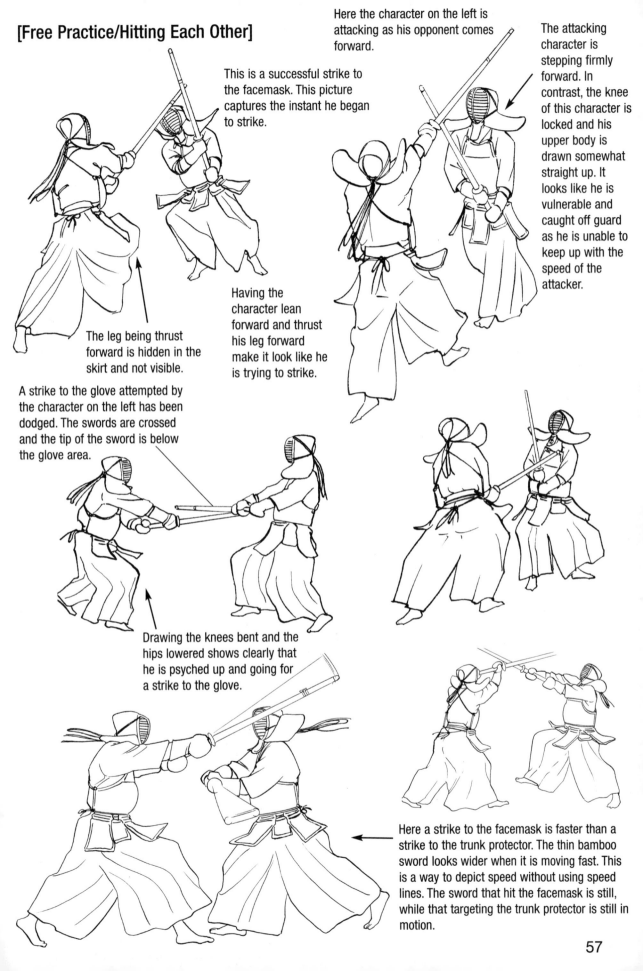

The leg being thrust forward is hidden in the skirt and not visible.

Having the character lean forward and thrust his leg forward make it look like he is trying to strike.

A strike to the glove attempted by the character on the left has been dodged. The swords are crossed and the tip of the sword is below the glove area.

Drawing the knees bent and the hips lowered shows clearly that he is psyched up and going for a strike to the glove.

Here a strike to the facemask is faster than a strike to the trunk protector. The thin bamboo sword looks wider when it is moving fast. This is a way to depict speed without using speed lines. The sword that hit the facemask is still, while that targeting the trunk protector is still in motion.

[Hitting Each Other - Pushing at Each Others Sword Guards]

The chin raised to one side will make it look like power is being exerted.

The length of the facemask cords officially has to be 40 cm or less (they should not quite reach the waist). In comics, they stream and look cool when drawn long.

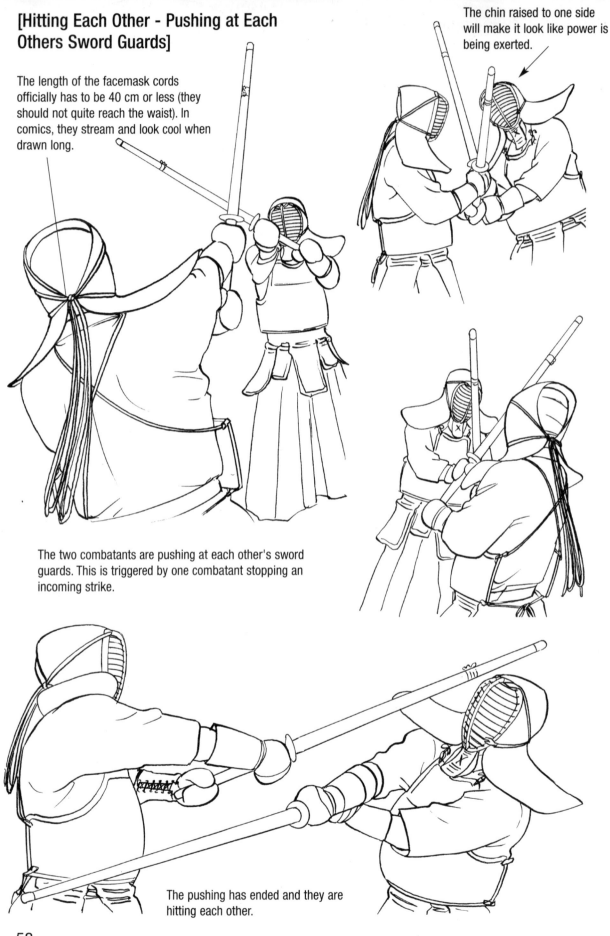

The two combatants are pushing at each other's sword guards. This is triggered by one combatant stopping an incoming strike.

The pushing has ended and they are hitting each other.

[Pushing at Each Others Sword Guards]

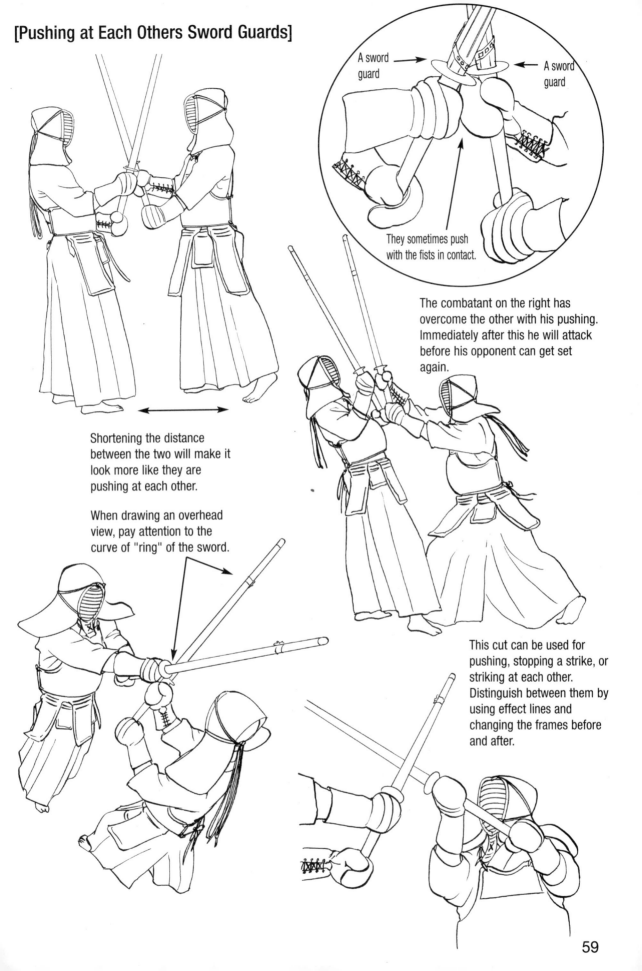

A sword guard →

← A sword guard

They sometimes push with the fists in contact.

The combatant on the right has overcome the other with his pushing. Immediately after this he will attack before his opponent can get set again.

Shortening the distance between the two will make it look more like they are pushing at each other.

When drawing an overhead view, pay attention to the curve of "ring" of the sword.

This cut can be used for pushing, stopping a strike, or striking at each other. Distinguish between them by using effect lines and changing the frames before and after.

[Striking]

A picture of the instant that a strike hits will be plenty effective even if some parts are trimmed.

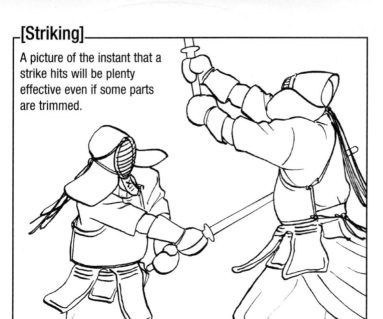

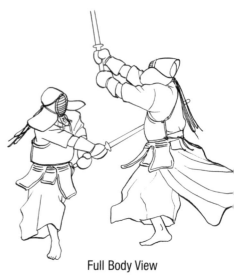

Full Body View

A strike to the trunk protector hits its target as the two pass each other.

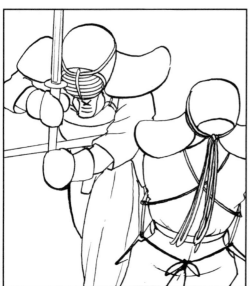

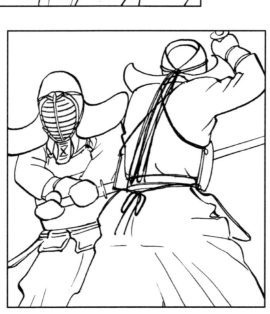

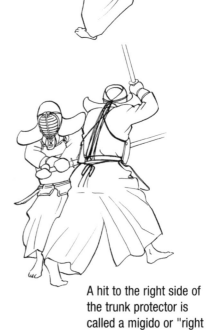

A hit to the right side of the trunk protector is called a migido or "right strike to the trunk protector."

This is the instant the strike to the trunk protector hits its target.

Strike with Underhand Grip

If the scene were a kendo match, this would be the cut of the winning technique, but if it were a real sword (samurai drama, etc.), the sword would not stop here. It would be harsh to show the torso being cut in two, so change the pose or angle by using a scene where the victor cuts down the opponent with the sword as is or a pose of the victor at the end of the sword stroke.

Feet Movements and Skirt

This is the position of the feet when ready to fight at the beginning of a match.

The bottom of the skirt is tucked up.

You can clearly see that the skirt is like trousers when the feet are opened wide.

[Putting on Equipment]
Putting on Practice Wear and Skirt

①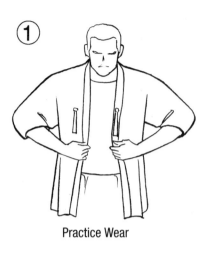

Practice Wear

②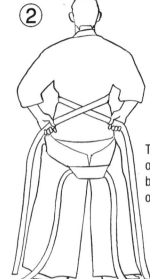

Tie the belt. Put on the skirt. The belt is crossed over at the back.

③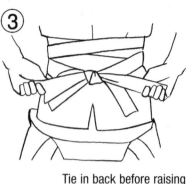

Tie in back before raising the skirt.

Practice Wear Knot

④ Tie the skirt belt after wrapping it around the front.

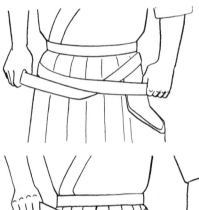

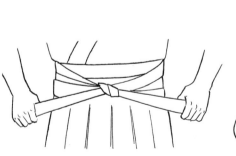

Putting on Hip Protector

①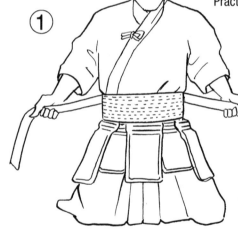

Put the hip protector on the top and tie the belt.

②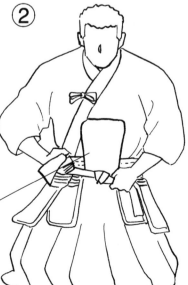

Tie below the hip protector.

③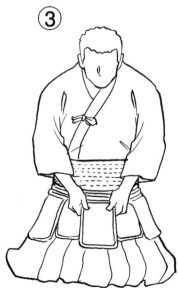

Putting on Trunk Protector

The trunk protector is attached with two cords.

The first cord crosses over at the back.

It looks like it is hung over the neck.

The second cord is simply tied.

[Waiting after Putting on Equipment]

The Sonkyo (Knee Bend Squat) Position

The sword being held at ready looks short when viewed from the front.

Guidelines for Drawing Bamboo Sword

The tip should be about shoulder height.

} The ring and the base of the handle can act as a guide.

The base is below the belly button.

You should draw the angle and length of the sword in relation to the body. Drawing reference lines makes it easier.

[Putting on Face Mask]

How to Wrap a Towel around Head

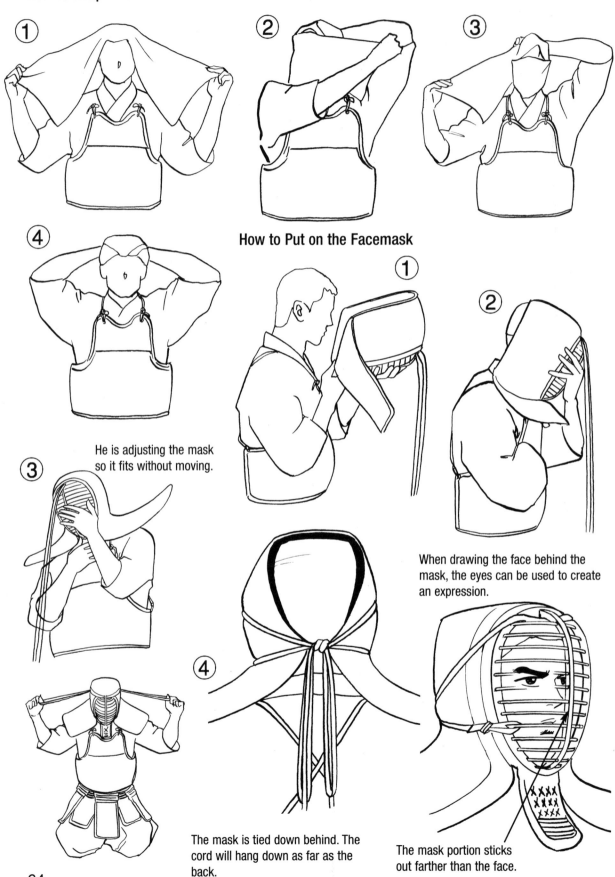

① ② ③

④

How to Put on the Facemask

①

He is adjusting the mask so it fits without moving.

②

③

④

When drawing the face behind the mask, the eyes can be used to create an expression.

The mask is tied down behind. The cord will hang down as far as the back.

The mask portion sticks out farther than the face.

[Equipment Style]

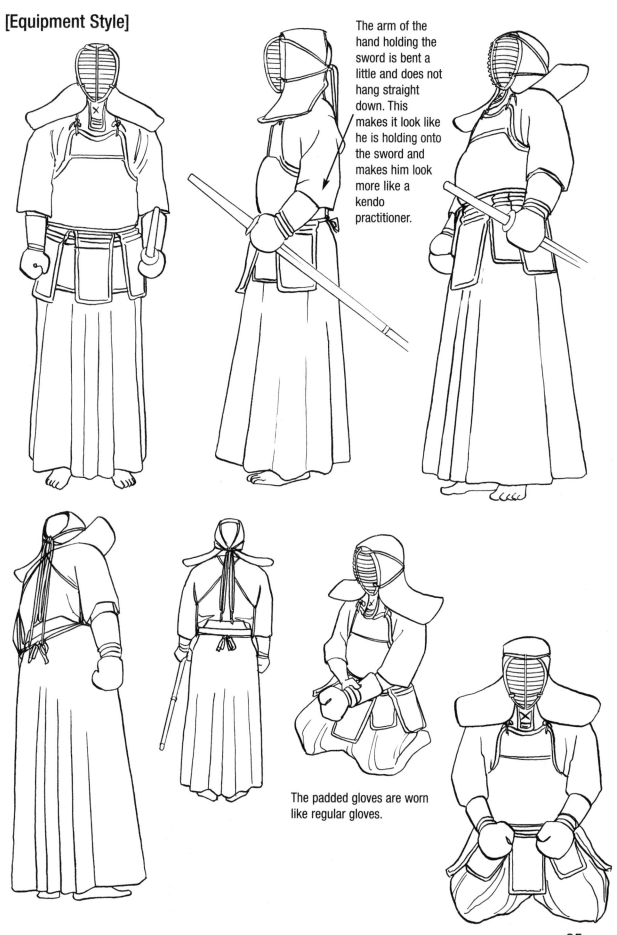

The arm of the hand holding the sword is bent a little and does not hang straight down. This makes it look like he is holding onto the sword and makes him look more like a kendo practitioner.

The padded gloves are worn like regular gloves.

[Various Stances]

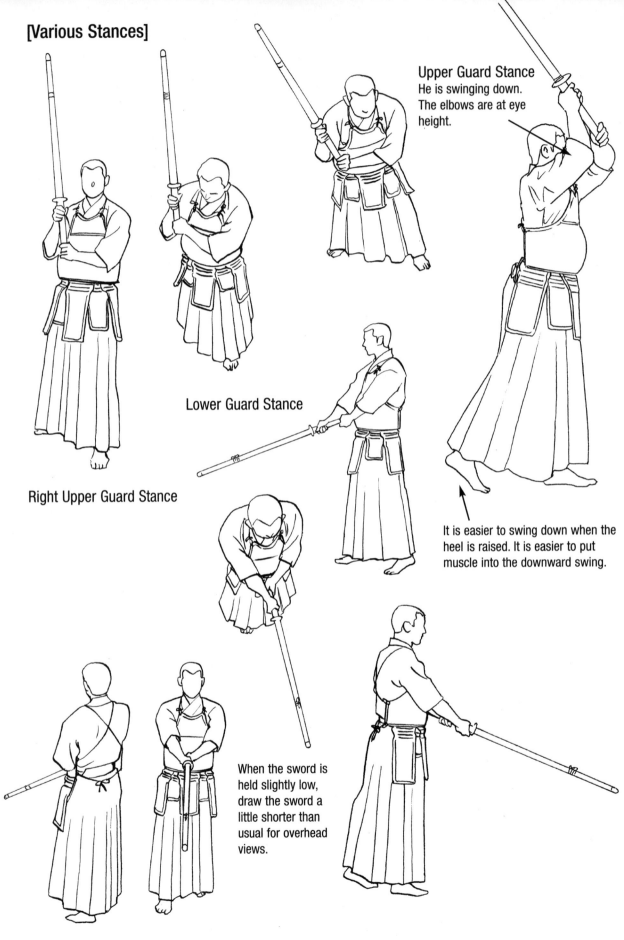

Right Upper Guard Stance

Lower Guard Stance

Upper Guard Stance
He is swinging down.
The elbows are at eye
height.

It is easier to swing down when the heel is raised. It is easier to put muscle into the downward swing.

When the sword is held slightly low, draw the sword a little shorter than usual for overhead views.

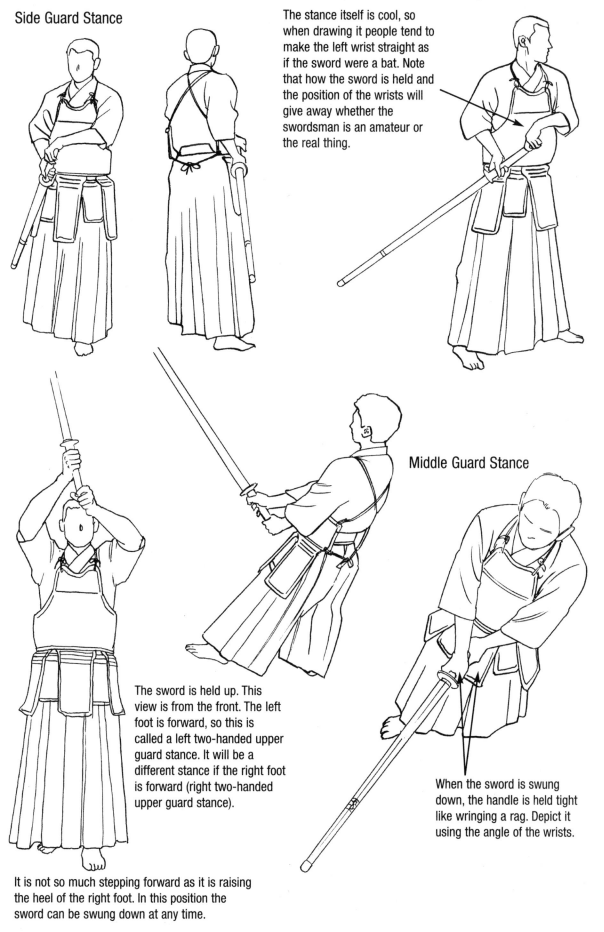

Side Guard Stance

The stance itself is cool, so when drawing it people tend to make the left wrist straight as if the sword were a bat. Note that how the sword is held and the position of the wrists will give away whether the swordsman is an amateur or the real thing.

Middle Guard Stance

The sword is held up. This view is from the front. The left foot is forward, so this is called a left two-handed upper guard stance. It will be a different stance if the right foot is forward (right two-handed upper guard stance).

When the sword is swung down, the handle is held tight like wringing a rag. Depict it using the angle of the wrists.

It is not so much stepping forward as it is raising the heel of the right foot. In this position the sword can be swung down at any time.

[Sitting]

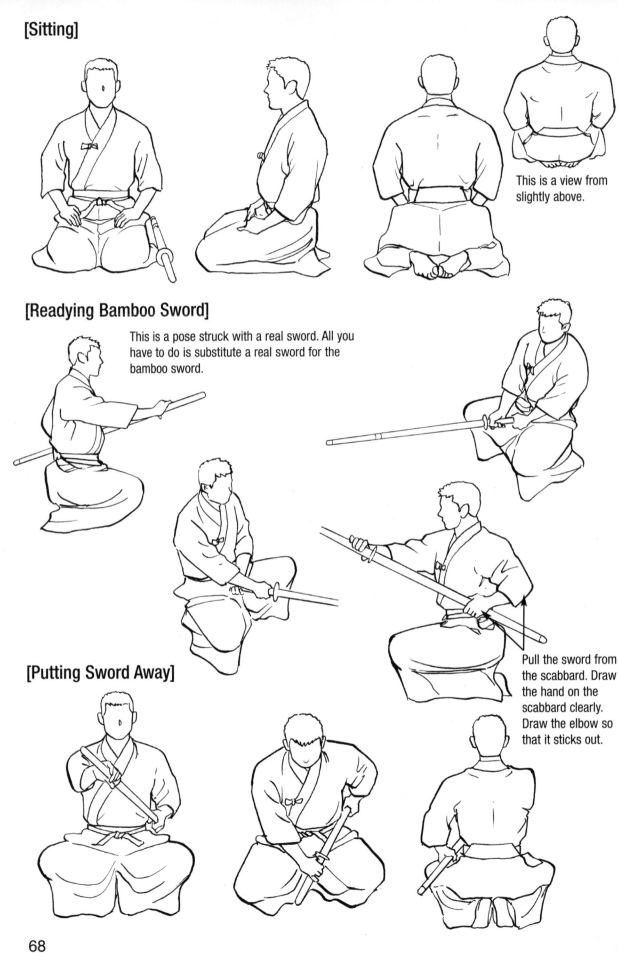

This is a view from slightly above.

[Readying Bamboo Sword]

This is a pose struck with a real sword. All you have to do is substitute a real sword for the bamboo sword.

Pull the sword from the scabbard. Draw the hand on the scabbard clearly. Draw the elbow so that it sticks out.

[Putting Sword Away]

[Striking the Air & Stance]

The practice wear looks like a kimono with shorter sleeves, so it can be used to draw a samurai wearing a ceremonial skirt or swordsman.

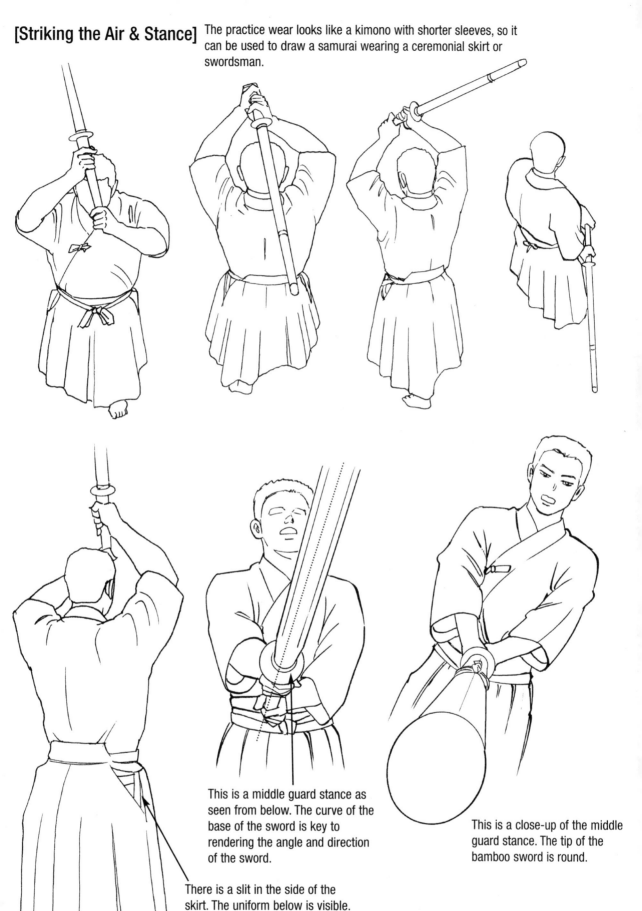

This is a middle guard stance as seen from below. The curve of the base of the sword is key to rendering the angle and direction of the sword.

There is a slit in the side of the skirt. The uniform below is visible.

This is a close-up of the middle guard stance. The tip of the bamboo sword is round.

[Walking with Sword]

The skirt covers the ankles, so often only one foot is visible when the view is from above.

[Bowing]

[Running & Moving with Practice Wear]

The cut at the front of the skirt is quite deep. Wrinkles emanate from near the crotch.

The cut at the back is shallow.

For a pose where the image appears to be flipped horizontally, the image cannot simply be inverted since the character is holding a sword.

[Practice Wear & Ceremonial Skirt]

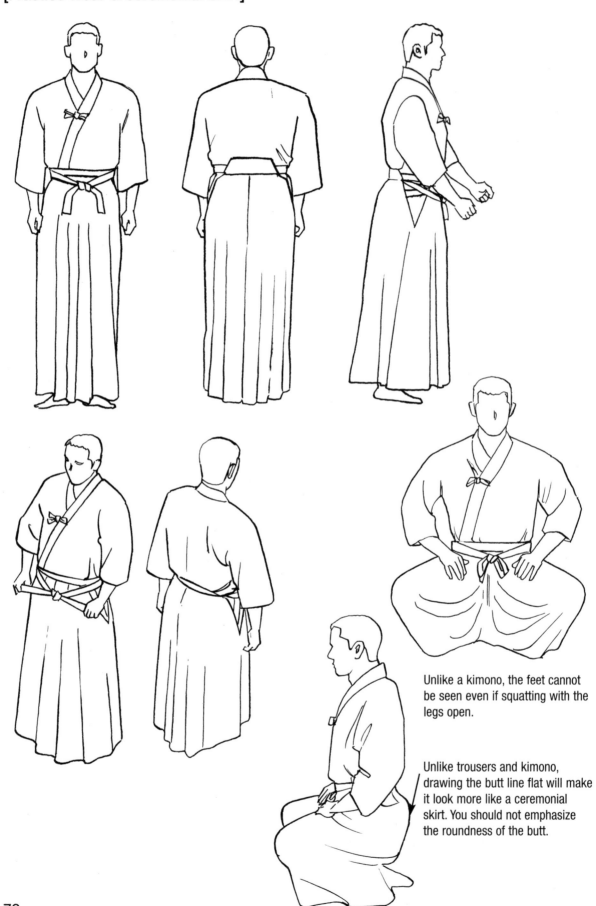

Unlike a kimono, the feet cannot be seen even if squatting with the legs open.

Unlike trousers and kimono, drawing the butt line flat will make it look more like a ceremonial skirt. You should not emphasize the roundness of the butt.

[Sitting, Bowing & Wiping with Cloth]

This is a deep bow from the sitting position.

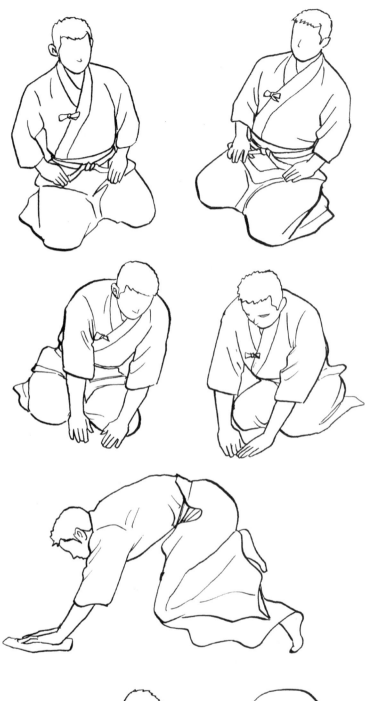

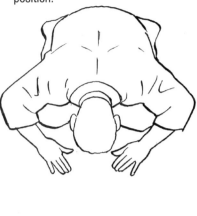

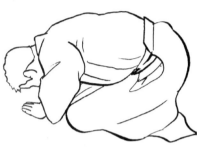

Drawing the back of the head small and like a half circle will make it look like the character is prostrating himself.

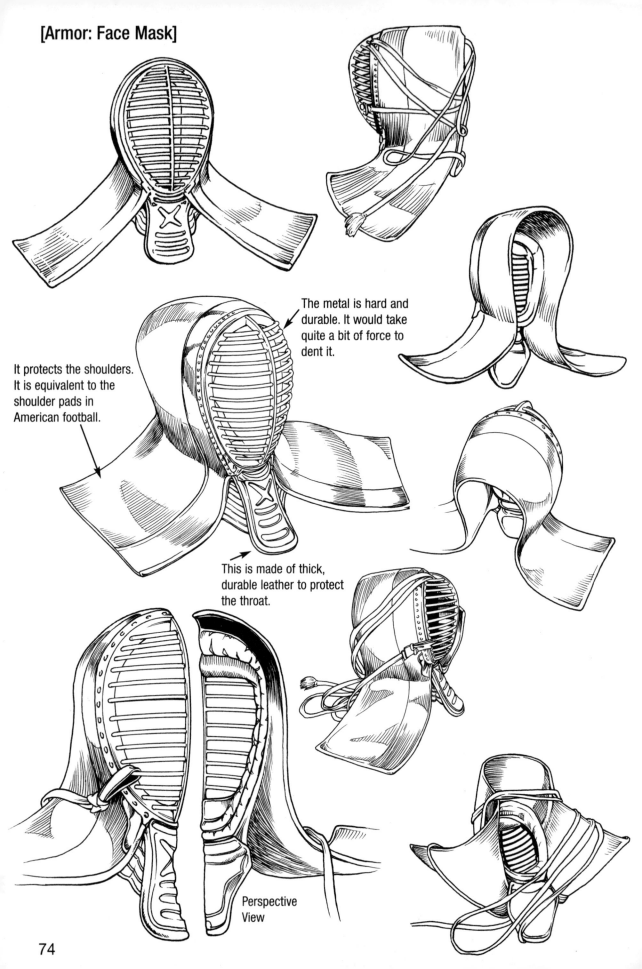

The metal is hard and durable. It would take quite a bit of force to dent it.

It protects the shoulders. It is equivalent to the shoulder pads in American football.

This is made of thick, durable leather to protect the throat.

Perspective View

[Trunk Protector, Hip Protector & Padded Gloves]

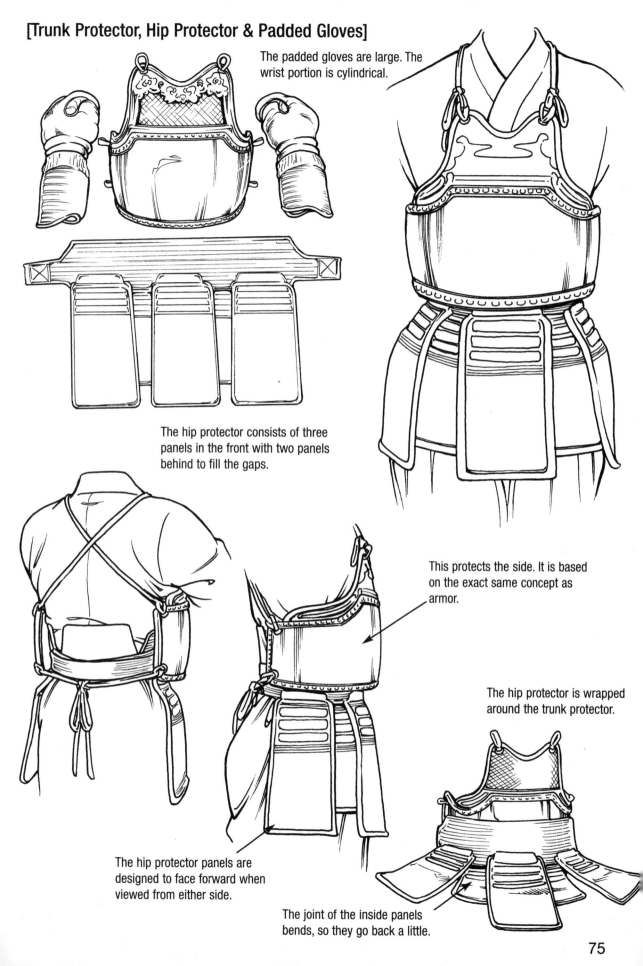

The padded gloves are large. The wrist portion is cylindrical.

The hip protector consists of three panels in the front with two panels behind to fill the gaps.

This protects the side. It is based on the exact same concept as armor.

The hip protector is wrapped around the trunk protector.

The hip protector panels are designed to face forward when viewed from either side.

The joint of the inside panels bends, so they go back a little.

[Trunk Protector]

The holes for the cord are made of leather cord.

Metal

[Hip Protector]

[Padded Gloves and Bamboo Sword]

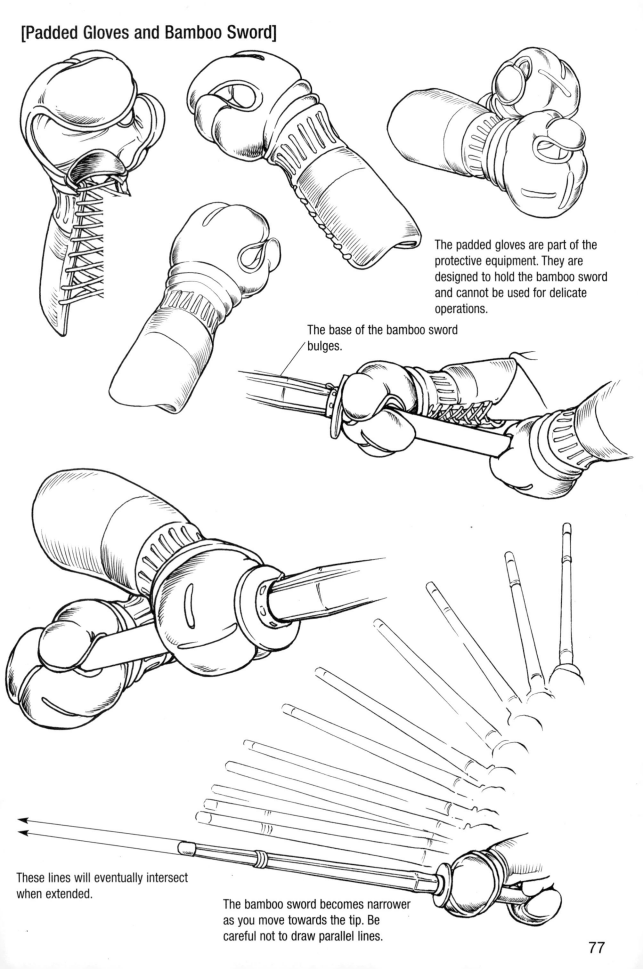

The padded gloves are part of the protective equipment. They are designed to hold the bamboo sword and cannot be used for delicate operations.

The base of the bamboo sword bulges.

These lines will eventually intersect when extended.

The bamboo sword becomes narrower as you move towards the tip. Be careful not to draw parallel lines.

[Bamboo Sword & Wooden Sword]

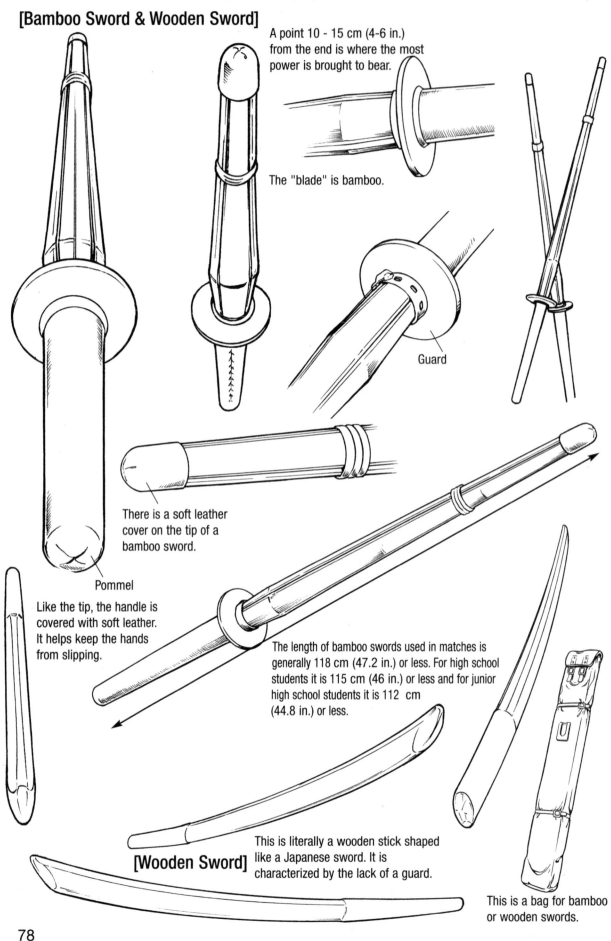

A point 10 - 15 cm (4-6 in.) from the end is where the most power is brought to bear.

The "blade" is bamboo.

Guard

There is a soft leather cover on the tip of a bamboo sword.

Pommel

Like the tip, the handle is covered with soft leather. It helps keep the hands from slipping.

The length of bamboo swords used in matches is generally 118 cm (47.2 in.) or less. For high school students it is 115 cm (46 in.) or less and for junior high school students it is 112 cm (44.8 in.) or less.

[Wooden Sword]

This is literally a wooden stick shaped like a Japanese sword. It is characterized by the lack of a guard.

This is a bag for bamboo or wooden swords.

[Kendo Contest Area]

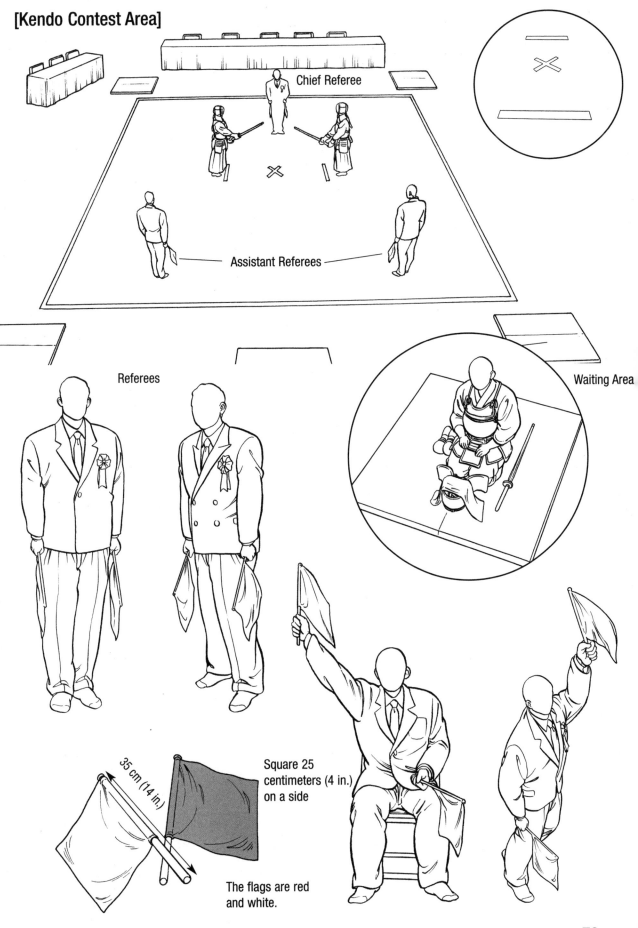

Chief Referee

Assistant Referees

Referees

Waiting Area

35 cm (14 in.)

Square 25 centimeters (4 in.) on a side

The flags are red and white.

Boxing

Make use of boxing for scenes with "punching" and "exchanging blows."

The origin of boxing is the primitive exchange of blows. It is alive today in the form of Westerns and street fights. Let's learn about the crunch of muscle being pounded and powerful compositions and poses.

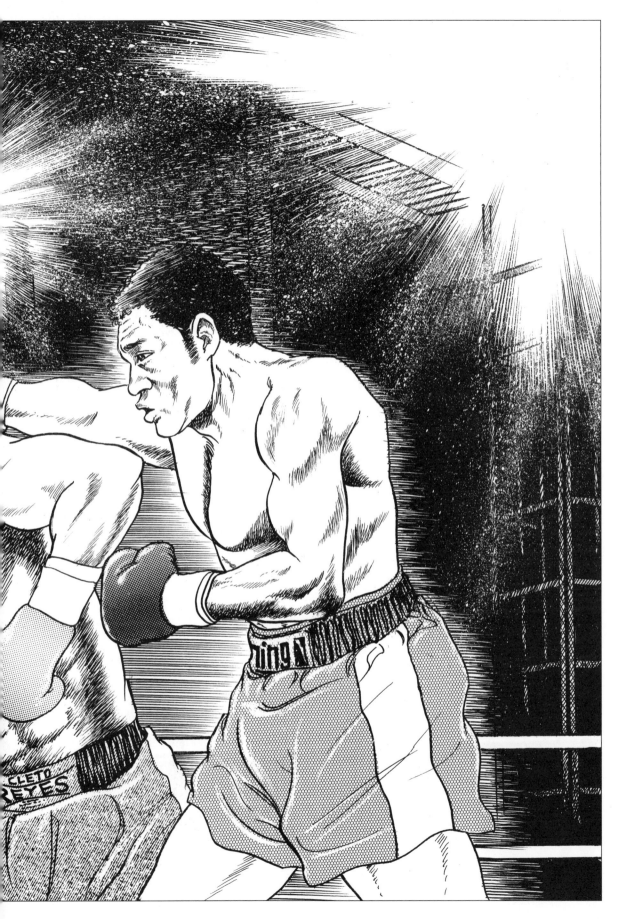

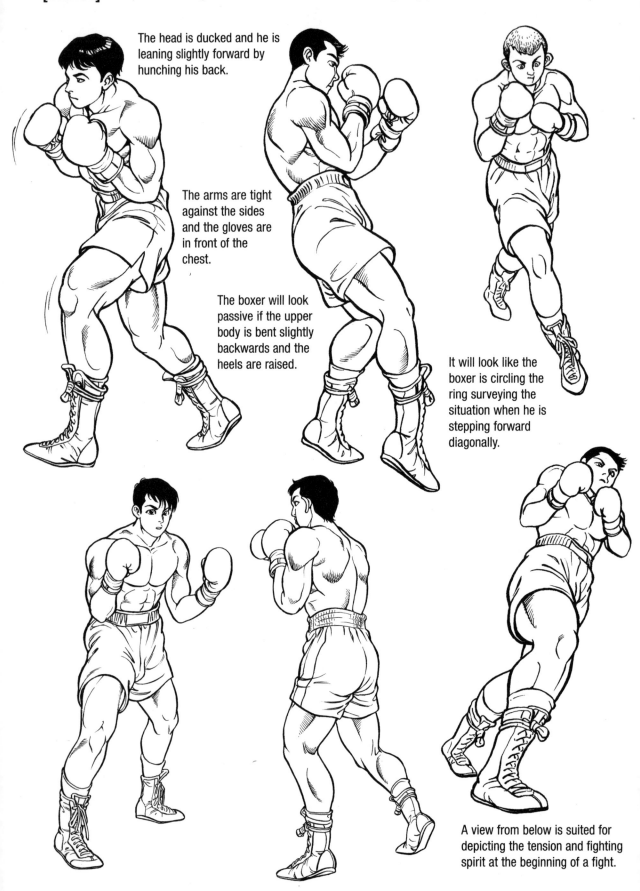

The head is ducked and he is leaning slightly forward by hunching his back.

The arms are tight against the sides and the gloves are in front of the chest.

The boxer will look passive if the upper body is bent slightly backwards and the heels are raised.

It will look like the boxer is circling the ring surveying the situation when he is stepping forward diagonally.

A view from below is suited for depicting the tension and fighting spirit at the beginning of a fight.

[Facing Each Other/Beginning of Fight]

An overhead view is perfect for conveying an objective scene.

You can draw the face of the opponent if you capture the back of one of the boxers from behind. The normal angle is often used for explanatory scenes or as the lead-in to an upcoming powerful scene.

The drawing has been trimmed. The situation or mood can be conveyed in one frame. You should draw a rough sketch of the whole body (including the parts that will be outside the frame) first.

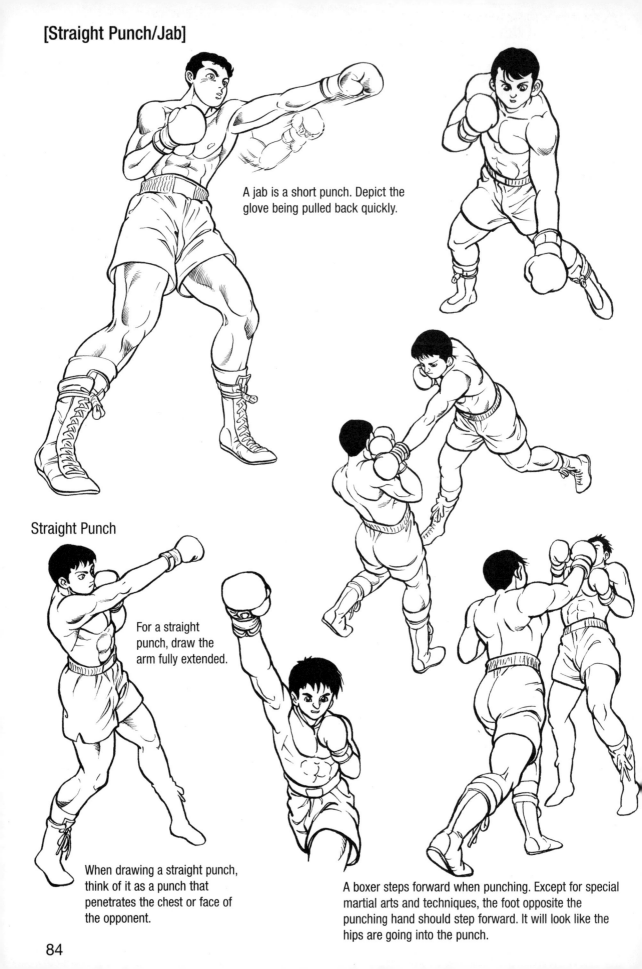

[Straight Punch/Jab]

A jab is a short punch. Depict the glove being pulled back quickly.

Straight Punch

For a straight punch, draw the arm fully extended.

When drawing a straight punch, think of it as a punch that penetrates the chest or face of the opponent.

A boxer steps forward when punching. Except for special martial arts and techniques, the foot opposite the punching hand should step forward. It will look like the hips are going into the punch.

Jabs are short, repetitive punches. They are often accompanied by punching sounds.

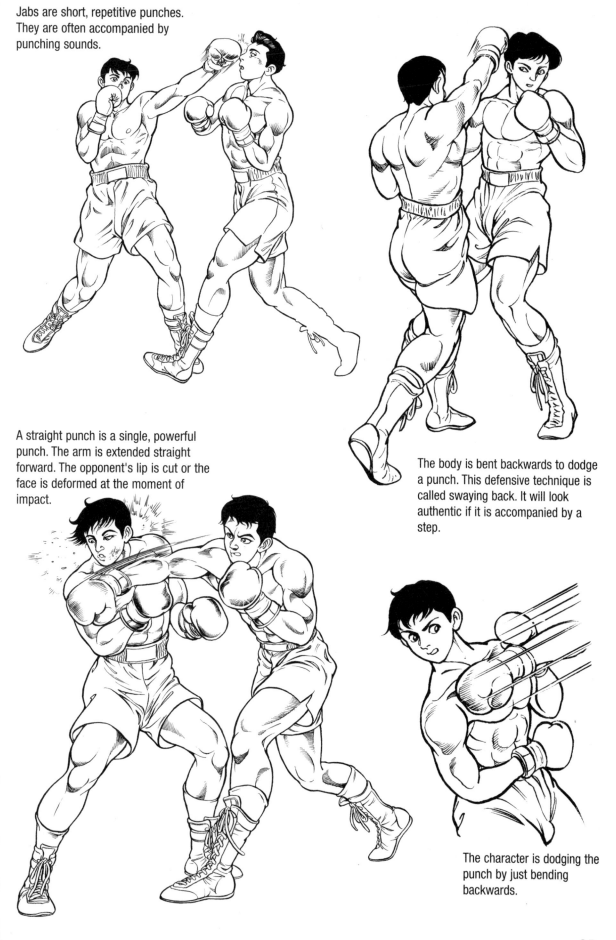

A straight punch is a single, powerful punch. The arm is extended straight forward. The opponent's lip is cut or the face is deformed at the moment of impact.

The body is bent backwards to dodge a punch. This defensive technique is called swaying back. It will look authentic if it is accompanied by a step.

The character is dodging the punch by just bending backwards.

[Uppercut/Body Blow]

The punch is directed upward with the arm bent 90 degrees. A blow to the chin is an uppercut. A hit to the stomach is a body blow.

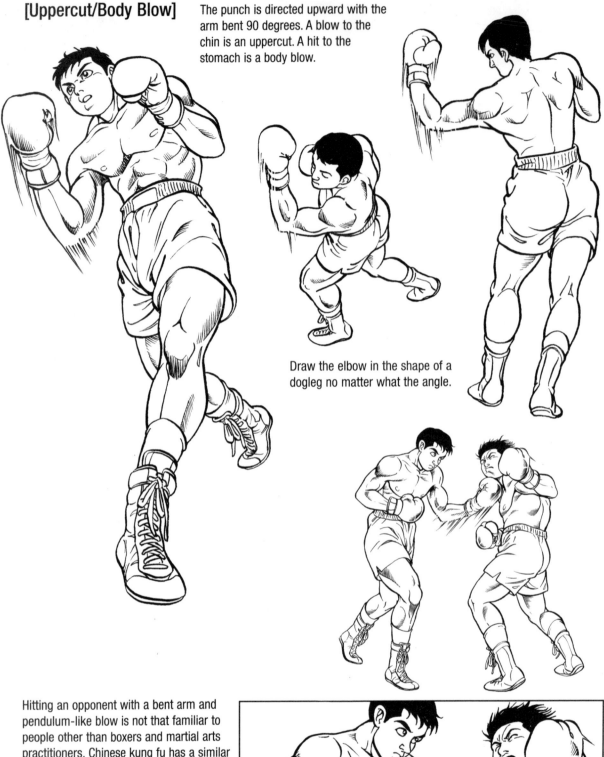

Draw the elbow in the shape of a dogleg no matter what the angle.

Hitting an opponent with a bent arm and pendulum-like blow is not that familiar to people other than boxers and martial arts practitioners. Chinese kung fu has a similar punch, but this punch is one of the easiest to use to visually create the feel of boxing. But, it is a short-range punch with a minimal windup, so visually it does not pack the punch that the actual blow does. For an uppercut, straightening the arm upward at the moment of impact like a straight punch will create a flashy image that is comic-like.

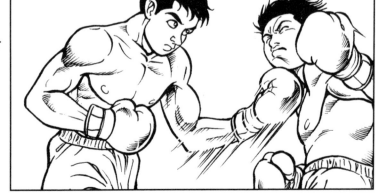

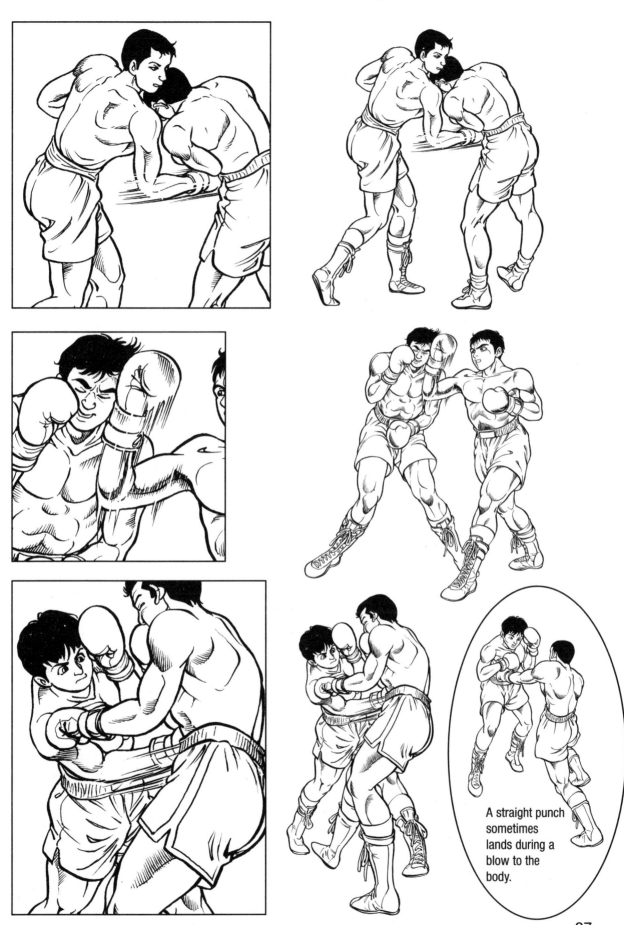

A straight punch sometimes lands during a blow to the body.

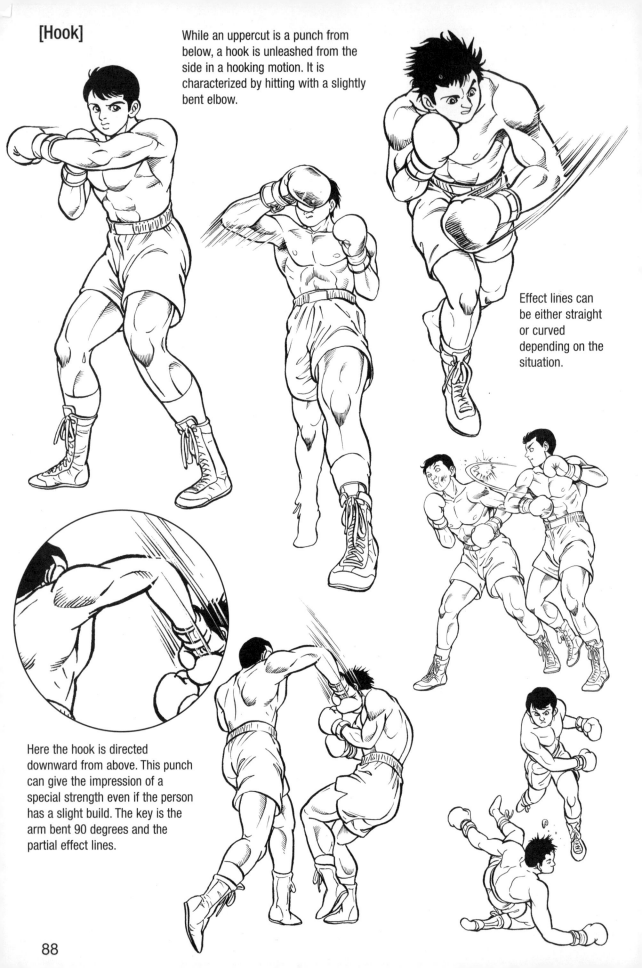

[Hook]

While an uppercut is a punch from below, a hook is unleashed from the side in a hooking motion. It is characterized by hitting with a slightly bent elbow.

Effect lines can be either straight or curved depending on the situation.

Here the hook is directed downward from above. This punch can give the impression of a special strength even if the person has a slight build. The key is the arm bent 90 degrees and the partial effect lines.

88

[Loss of Will to Fight/Knockdown]

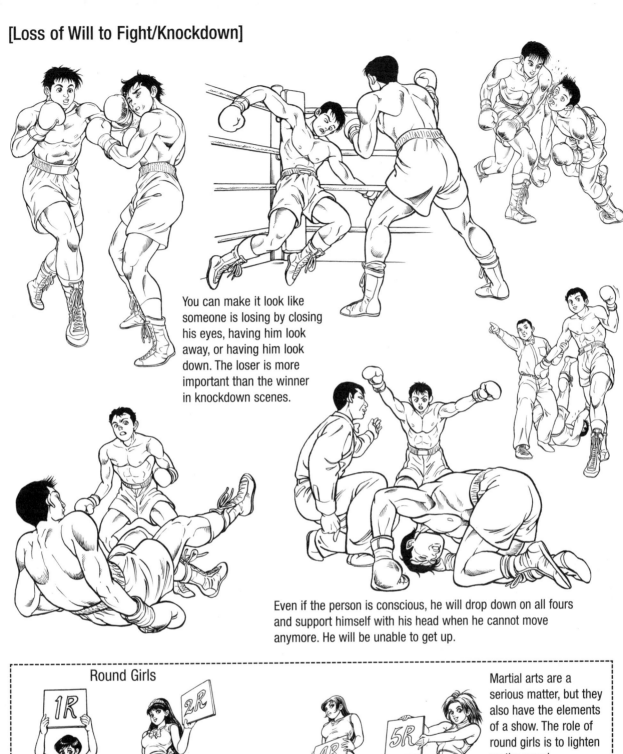

You can make it look like someone is losing by closing his eyes, having him look away, or having him look down. The loser is more important than the winner in knockdown scenes.

Even if the person is conscious, he will drop down on all fours and support himself with his head when he cannot move anymore. He will be unable to get up.

Round Girls

Martial arts are a serious matter, but they also have the elements of a show. The role of round girls is to lighten up the mood.

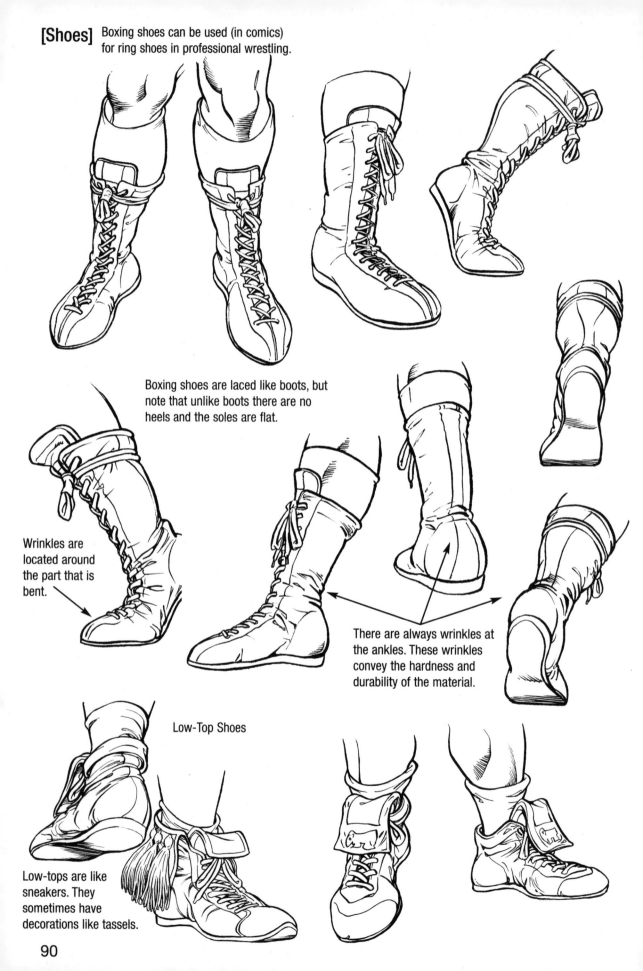

[Shoes] Boxing shoes can be used (in comics) for ring shoes in professional wrestling.

Boxing shoes are laced like boots, but note that unlike boots there are no heels and the soles are flat.

Wrinkles are located around the part that is bent.

There are always wrinkles at the ankles. These wrinkles convey the hardness and durability of the material.

Low-Top Shoes

Low-tops are like sneakers. They sometimes have decorations like tassels.

[Gloves]

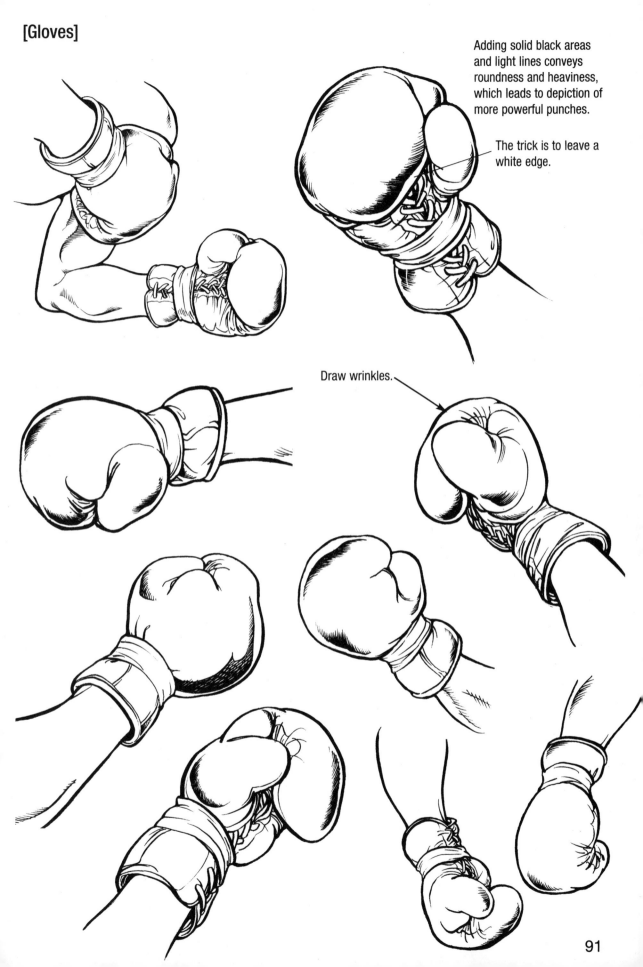

Adding solid black areas and light lines conveys roundness and heaviness, which leads to depiction of more powerful punches.

The trick is to leave a white edge.

Draw wrinkles.

[Trunks]

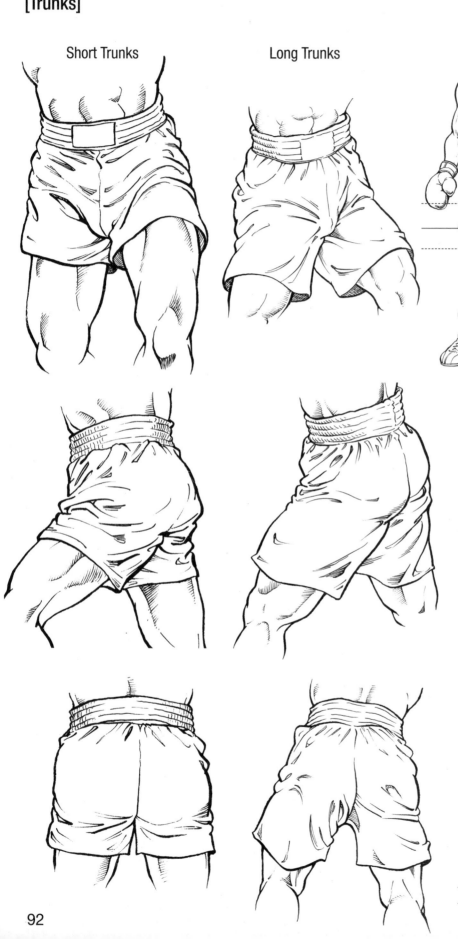

Short Trunks

Long Trunks

Normal Length

The standard length is about midway between the crotch and knees. Those shorter than this are "short trunks" and those longer are "long trunks." They normally do not have slits in the side.

Trunks with Slits

KAYASHI

There are slits on the side. These trunks are fashionable.

[Bandages]

A bandage is fabric that is wrapped around the fists and joints to protect them.

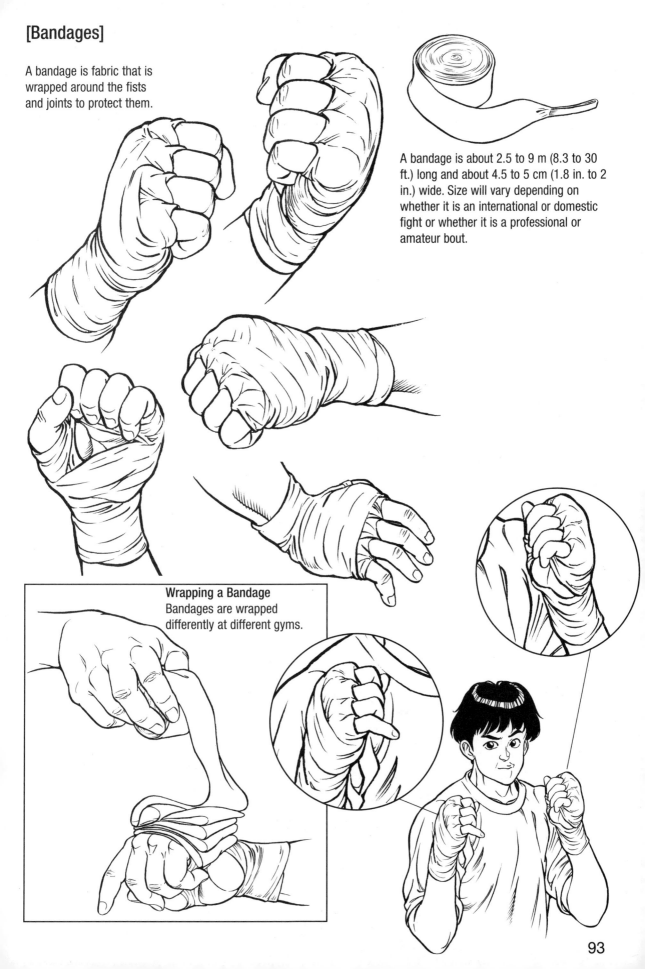

A bandage is about 2.5 to 9 m (8.3 to 30 ft.) long and about 4.5 to 5 cm (1.8 in. to 2 in.) wide. Size will vary depending on whether it is an international or domestic fight or whether it is a professional or amateur bout.

Wrapping a Bandage
Bandages are wrapped differently at different gyms.

Headgear
This protects the ears and head.

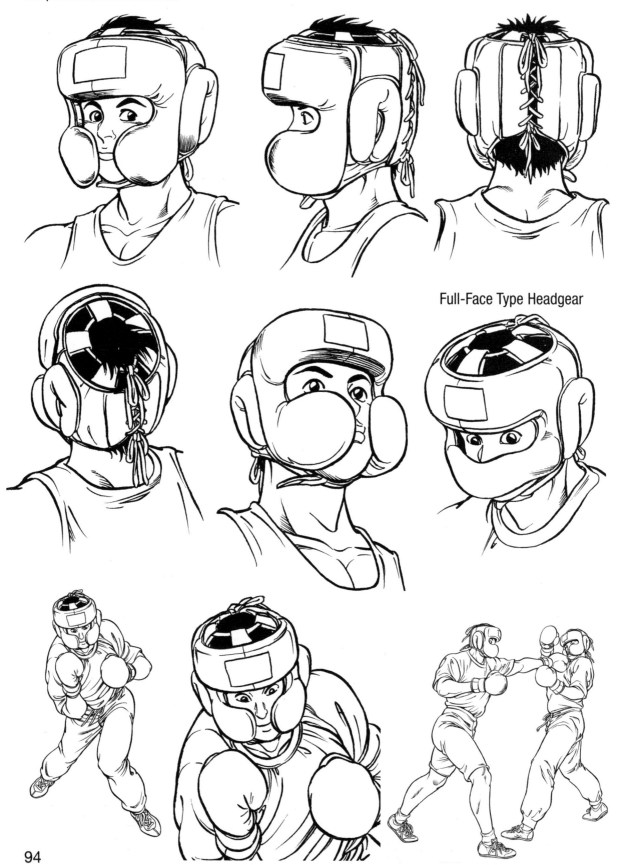

Full-Face Type Headgear

Mitts

The trainer or sparing partner wears these for mitt training.

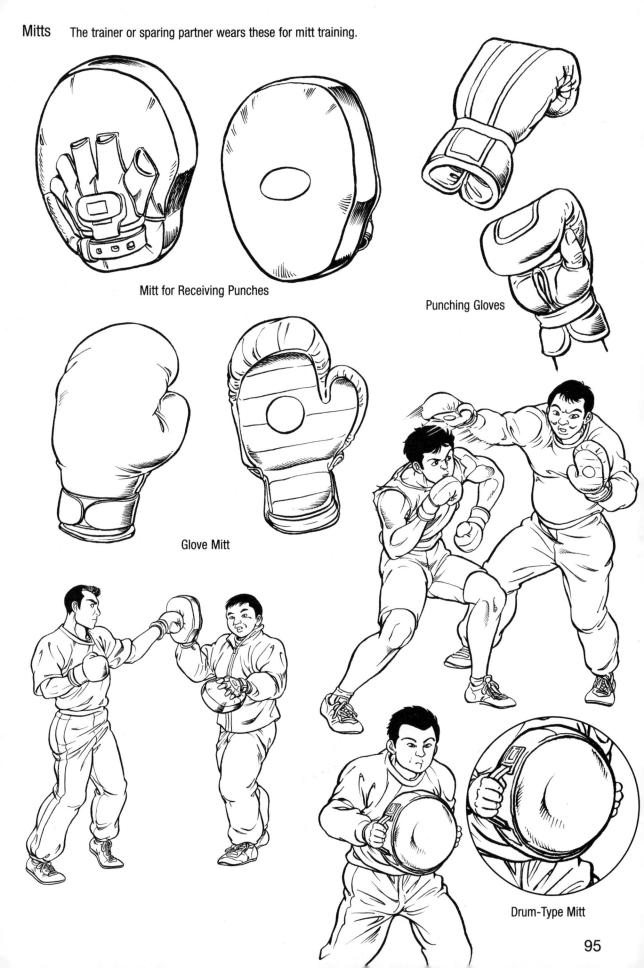

Mitt for Receiving Punches

Punching Gloves

Glove Mitt

Drum-Type Mitt

Sandbag

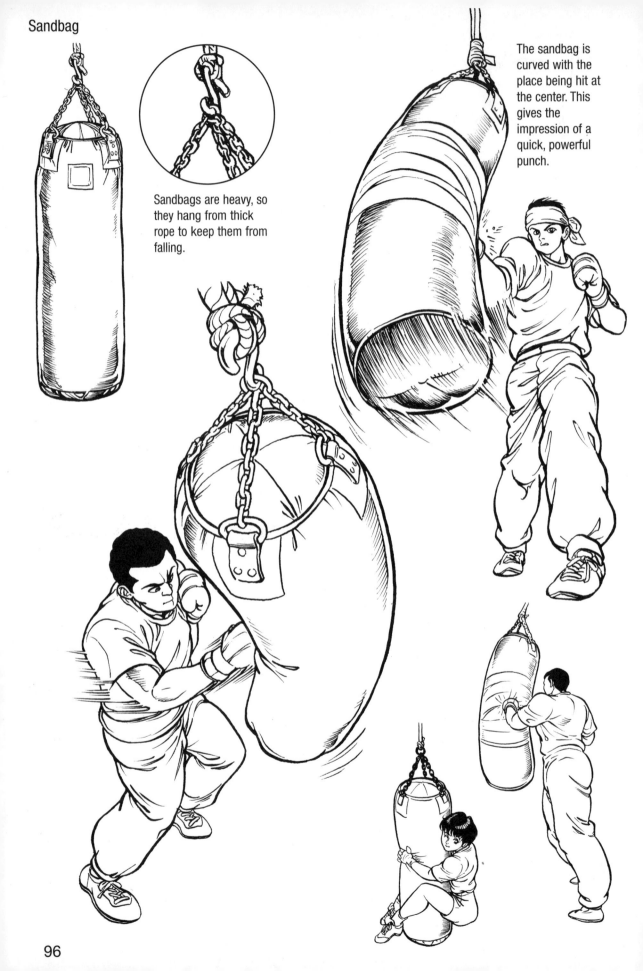

Sandbags are heavy, so they hang from thick rope to keep them from falling.

The sandbag is curved with the place being hit at the center. This gives the impression of a quick, powerful punch.

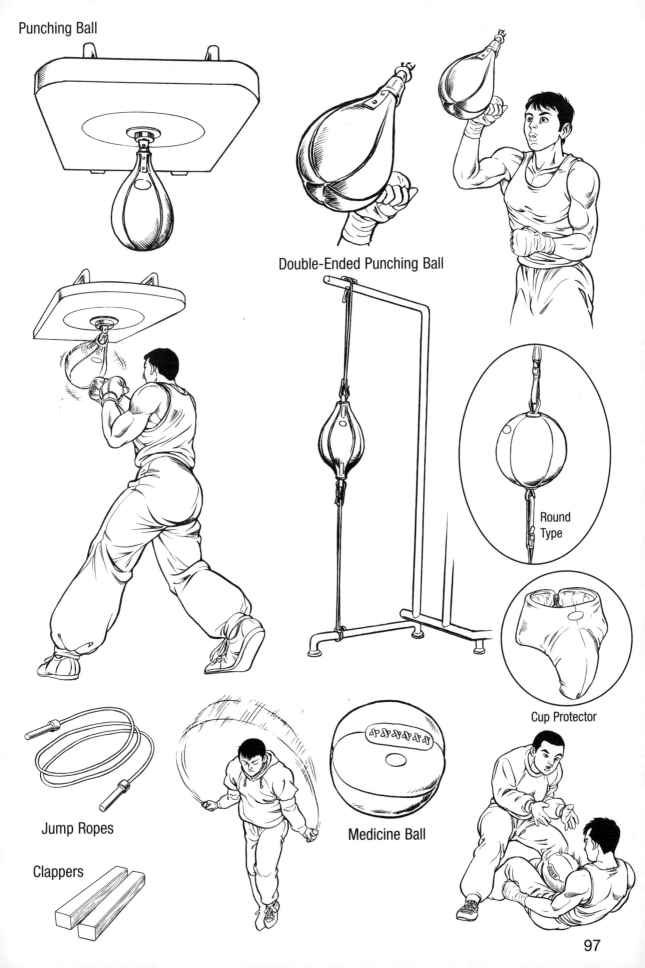

Punching Ball

Double-Ended Punching Ball

Round Type

Cup Protector

Jump Ropes

Clappers

Medicine Ball

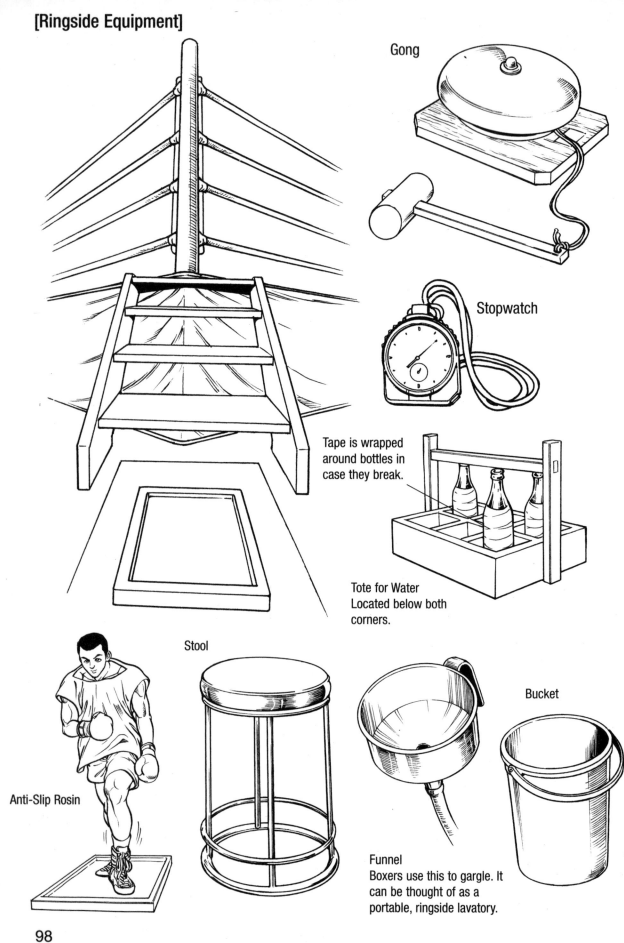

[Ringside Equipment]

Gong

Stopwatch

Tape is wrapped around bottles in case they break.

Tote for Water
Located below both corners.

Stool

Anti-Slip Rosin

Bucket

Funnel
Boxers use this to gargle. It can be thought of as a portable, ringside lavatory.

98

Petroleum Jelly

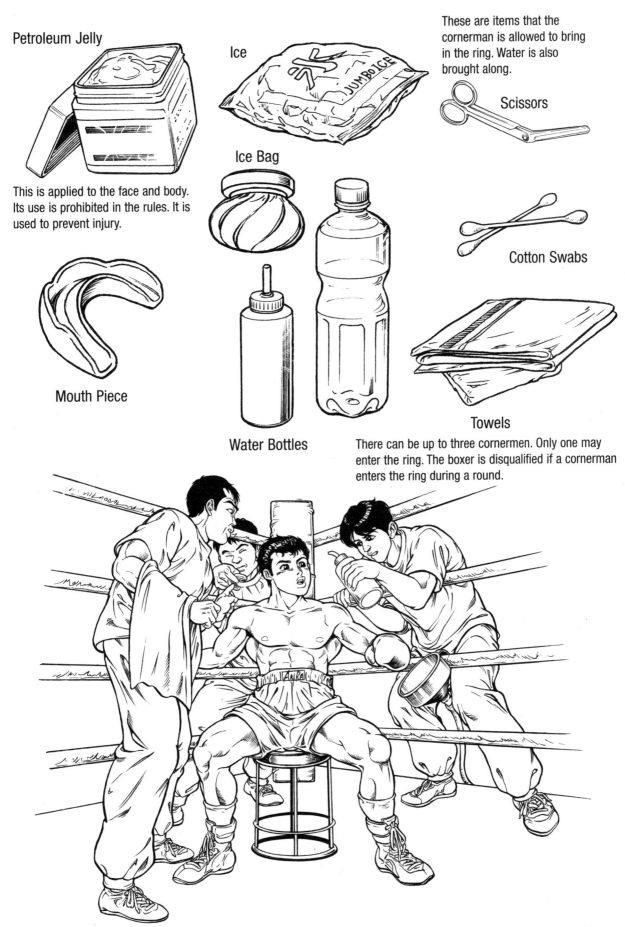

This is applied to the face and body. Its use is prohibited in the rules. It is used to prevent injury.

Ice

Ice Bag

Mouth Piece

Water Bottles

These are items that the cornerman is allowed to bring in the ring. Water is also brought along.

Scissors

Cotton Swabs

Towels

There can be up to three cornermen. Only one may enter the ring. The boxer is disqualified if a cornerman enters the ring during a round.

"Drawing is impossible unless a rough sketch is drawn first. Rough sketches are important."

Rough sketches will differ depending on the person. Some pencil sketches may be almost exactly the same as the drawing that is eventually penned in, while some may have so many lines that only the person who drew it could possibly pen it in. The term rough sketch used here refers to "clarifying the image of the completed drawing and grasping the appearance/state of what you will draw," which is extremely important.

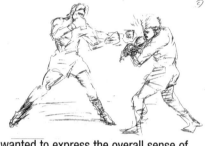

"I wanted to express the overall sense of speed of a jab. I drew the person being hit on the right first. I wanted to make it look like he was getting smacked in the face, so I made it look like he was moving. When drawing the person on the left, the goal is to make it look like he is moving even faster than the other person."

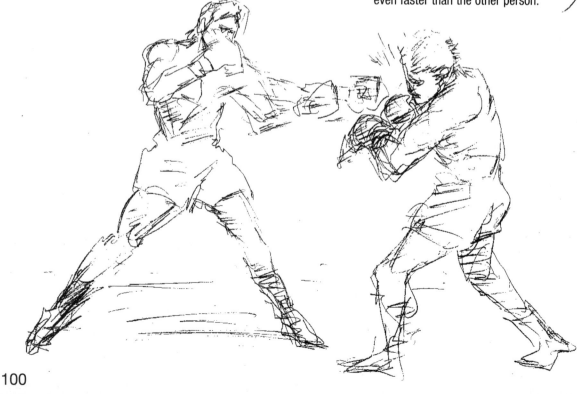

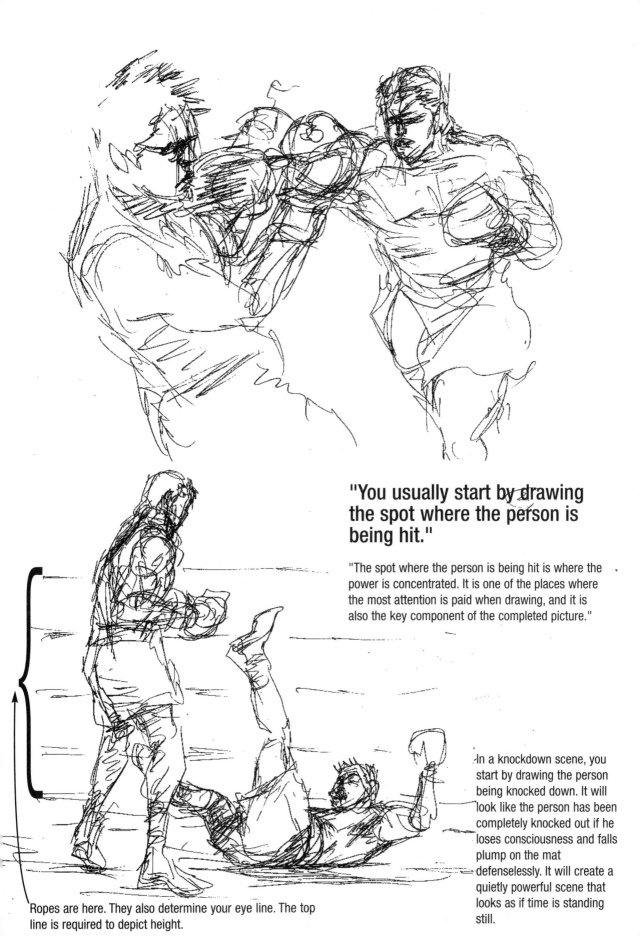

"You usually start by drawing the spot where the person is being hit."

"The spot where the person is being hit is where the power is concentrated. It is one of the places where the most attention is paid when drawing, and it is also the key component of the completed picture."

In a knockdown scene, you start by drawing the person being knocked down. It will look like the person has been completely knocked out if he loses consciousness and falls plump on the mat defenselessly. It will create a quietly powerful scene that looks as if time is standing still.

Ropes are here. They also determine your eye line. The top line is required to depict height.

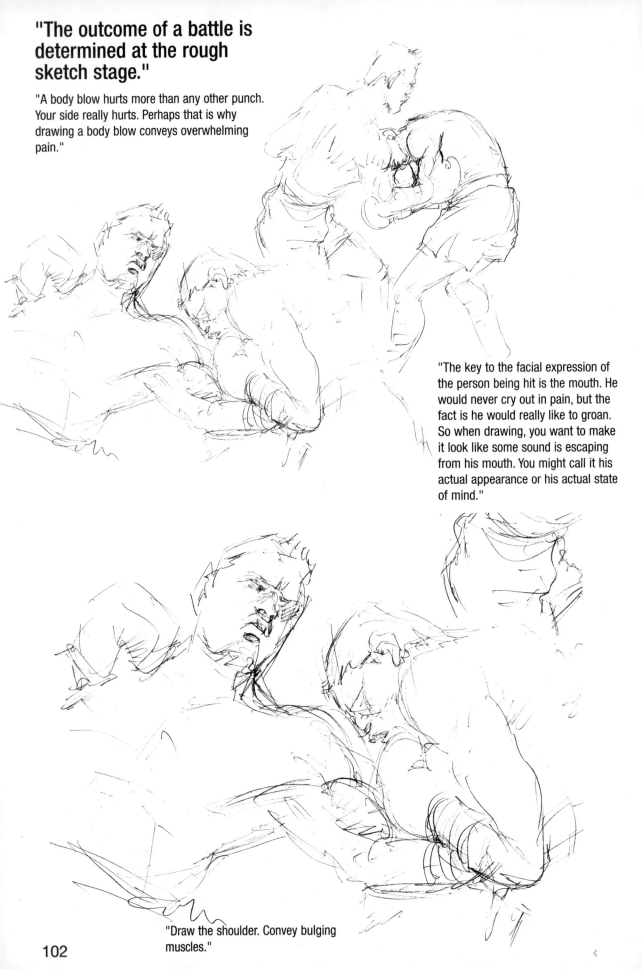

"The outcome of a battle is determined at the rough sketch stage."

"A body blow hurts more than any other punch. Your side really hurts. Perhaps that is why drawing a body blow conveys overwhelming pain."

"The key to the facial expression of the person being hit is the mouth. He would never cry out in pain, but the fact is he would really like to groan. So when drawing, you want to make it look like some sound is escaping from his mouth. You might call it his actual appearance or his actual state of mind."

"Draw the shoulder. Convey bulging muscles."

102

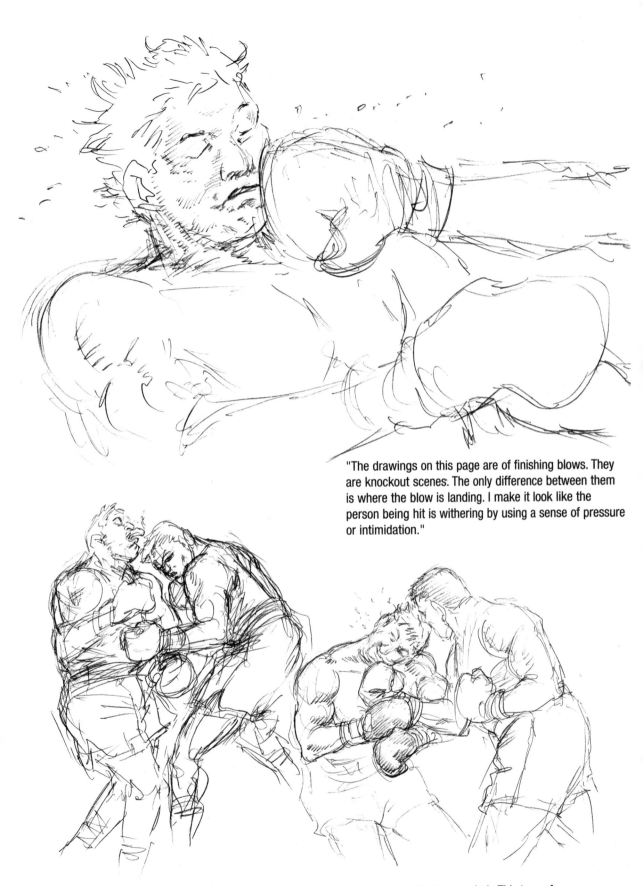

"The drawings on this page are of finishing blows. They are knockout scenes. The only difference between them is where the blow is landing. I make it look like the person being hit is withering by using a sense of pressure or intimidation."

"I look at pictures of different poses for reference. I change the angle or add/take away hair. This type of scene really calls for some drawn letters. Drawn letters will greatly increase the atmosphere."

[Training Equipment]

Scenes of people working out to get stronger are common in comics other than martial arts comics as well. Learn the basics in order to come up with your own original training scenes.

Barbells

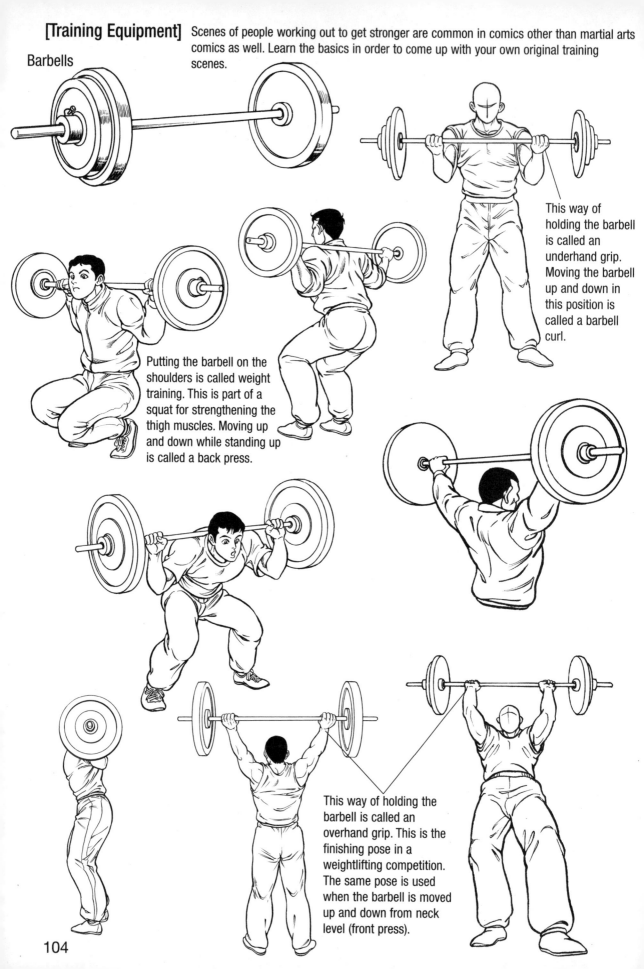

This way of holding the barbell is called an underhand grip. Moving the barbell up and down in this position is called a barbell curl.

Putting the barbell on the shoulders is called weight training. This is part of a squat for strengthening the thigh muscles. Moving up and down while standing up is called a back press.

This way of holding the barbell is called an overhand grip. This is the finishing pose in a weightlifting competition. The same pose is used when the barbell is moved up and down from neck level (front press).

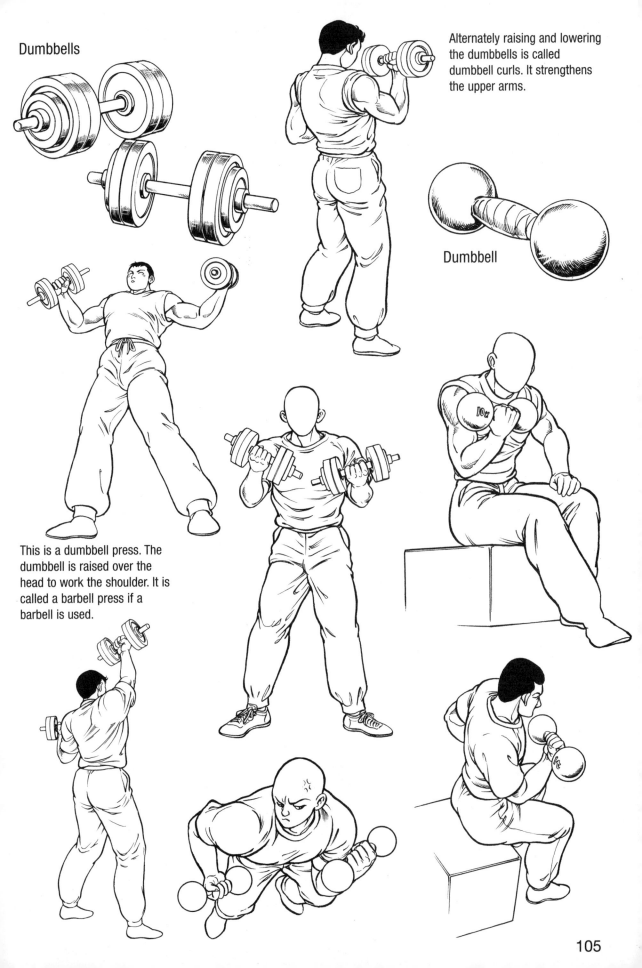

Dumbbells

Alternately raising and lowering the dumbbells is called dumbbell curls. It strengthens the upper arms.

Dumbbell

This is a dumbbell press. The dumbbell is raised over the head to work the shoulder. It is called a barbell press if a barbell is used.

Bench Press

The bench press is used to train the upper body. It is called dumbbell press when dumbbells are used.

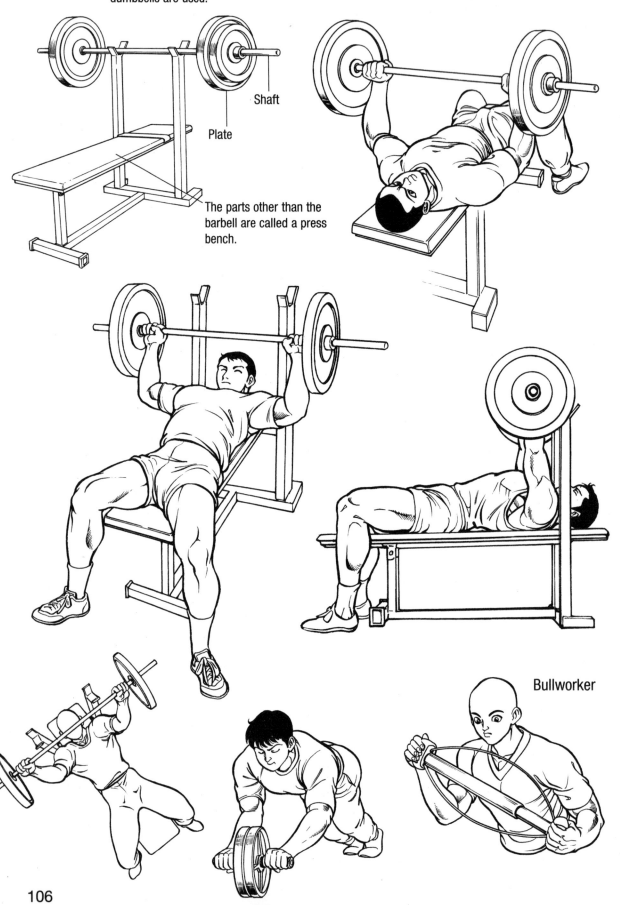

Shaft

Plate

The parts other than the barbell are called a press bench.

Bullworker

Exercise Bike

It is used for warming up and exercising.

Lat Machine

Sitting and pulling down the bar is called lat machine pull downs. It strengthens the upper back.

There are a number of different uses. For instance, you can stand up and push the bar down.

Butterfly

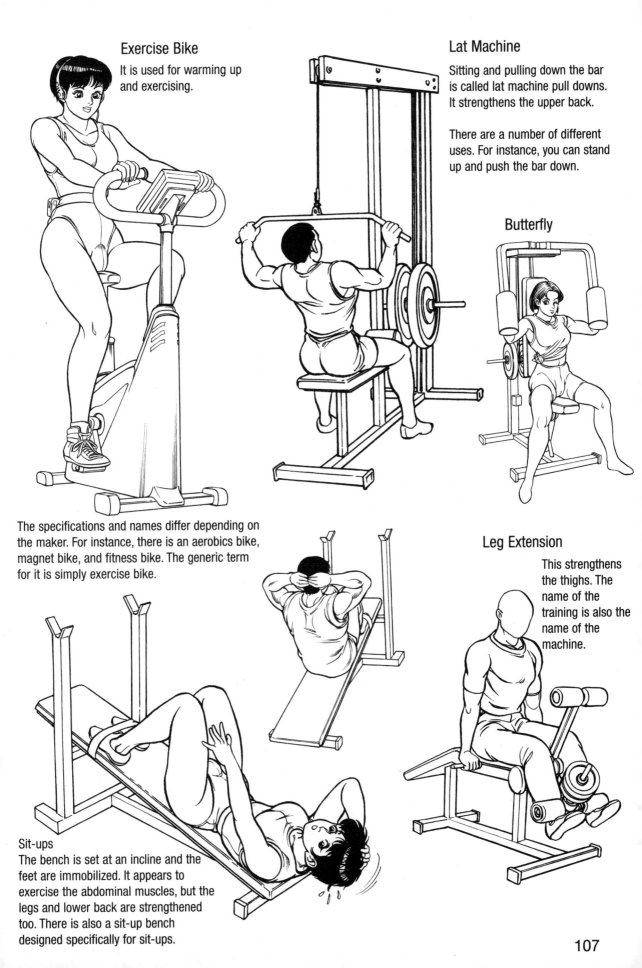

The specifications and names differ depending on the maker. For instance, there is an aerobics bike, magnet bike, and fitness bike. The generic term for it is simply exercise bike.

Leg Extension

This strengthens the thighs. The name of the training is also the name of the machine.

Sit-ups

The bench is set at an incline and the feet are immobilized. It appears to exercise the abdominal muscles, but the legs and lower back are strengthened too. There is also a sit-up bench designed specifically for sit-ups.

Street Battles

Learn from the wrinkles and movement of clothing. Drawing the bad guy in a way that makes it look like he is really being beaten brings out the strength and coolness of the protagonist.

The location of martial arts matches is fixed. The attire is pretty much fixed as well. A real battle, however, can suddenly occur anywhere with only the barest necessities. The important part of fight scenes in street clothes is the wrinkles and movement of clothing. Also, empathize with the person being beaten when drawing. That will bring out the strength and coolness of the protagonist and make the action convincing.

Do a good job on the backgrounds of street battles. The background, i.e., puddles of water and alleys, is what most distinguishes a street battle from normal martial arts.

Understand movement when drawing battle scenes.

(1) Opponent Grabbing Collar

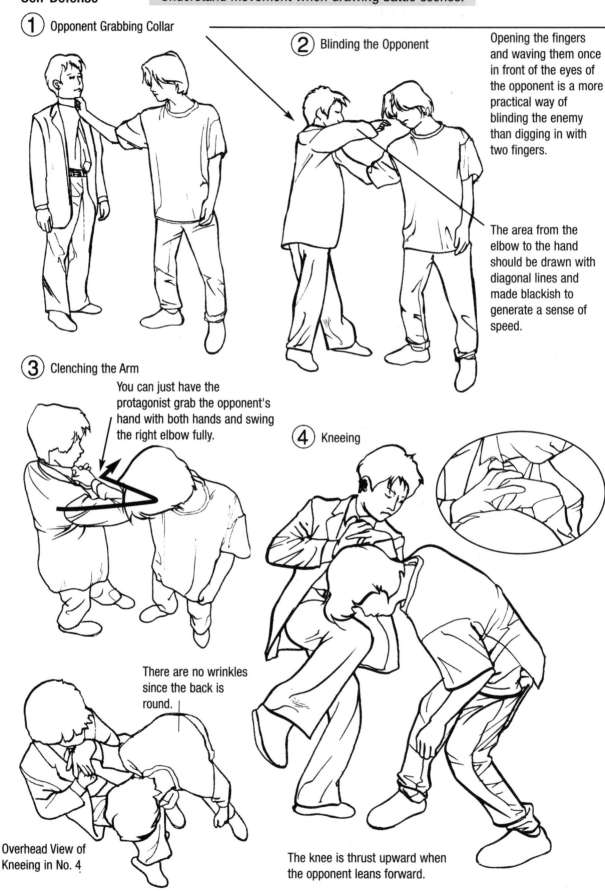

(2) Blinding the Opponent

Opening the fingers and waving them once in front of the eyes of the opponent is a more practical way of blinding the enemy than digging in with two fingers.

The area from the elbow to the hand should be drawn with diagonal lines and made blackish to generate a sense of speed.

(3) Clenching the Arm

You can just have the protagonist grab the opponent's hand with both hands and swing the right elbow fully.

(4) Kneeing

There are no wrinkles since the back is round.

Overhead View of Kneeing in No. 4

The knee is thrust upward when the opponent leans forward.

② Elbowing

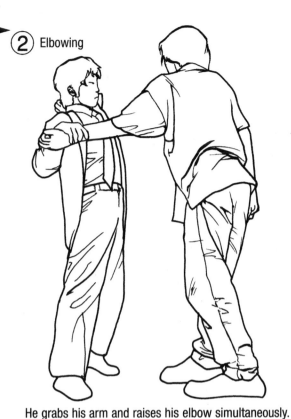

He grabs his arm and raises his elbow simultaneously.

③ Type A: He swings the elbow down from above with all his strength.

You can distinguish them by the direction of the effect lines and the aspect of the opponent's head.

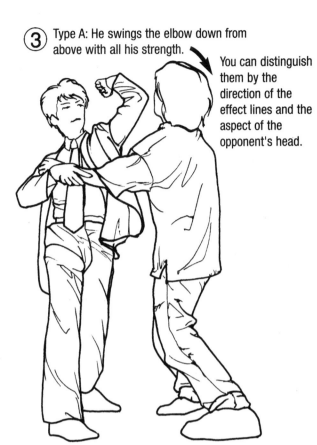

Use effect lines that make it look like the protagonist is rotating to the right. Messing up the hair of the opponent more would be effective.

③ Type B: He uses rotation of the hips to hit the side of the face with an elbow

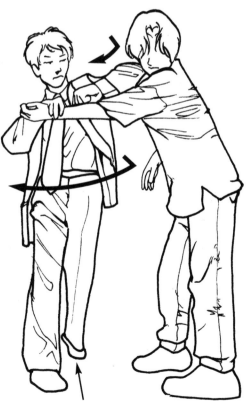

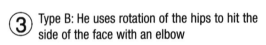

The heel is up because the leg is fully extended.

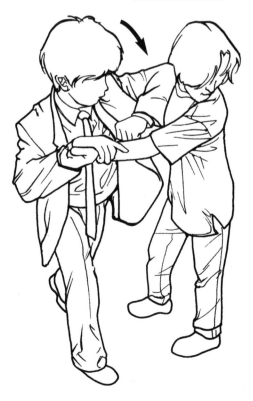

Close-Quarter Fighting

Guarding

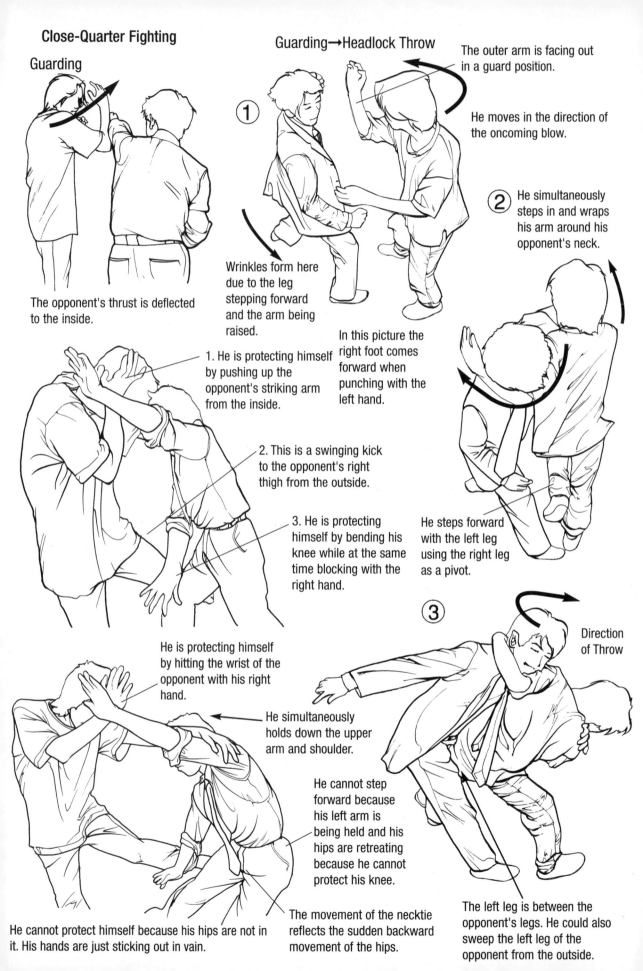

The opponent's thrust is deflected to the inside.

Guarding→Headlock Throw

① Wrinkles form here due to the leg stepping forward and the arm being raised.

The outer arm is facing out in a guard position.

He moves in the direction of the oncoming blow.

② He simultaneously steps in and wraps his arm around his opponent's neck.

In this picture the right foot comes forward when punching with the left hand.

He steps forward with the left leg using the right leg as a pivot.

1. He is protecting himself by pushing up the opponent's striking arm from the inside.

2. This is a swinging kick to the opponent's right thigh from the outside.

3. He is protecting himself by bending his knee while at the same time blocking with the right hand.

He is protecting himself by hitting the wrist of the opponent with his right hand.

He simultaneously holds down the upper arm and shoulder.

He cannot step forward because his left arm is being held and his hips are retreating because he cannot protect his knee.

③ Direction of Throw

He cannot protect himself because his hips are not in it. His hands are just sticking out in vain.

The movement of the necktie reflects the sudden backward movement of the hips.

The left leg is between the opponent's legs. He could also sweep the left leg of the opponent from the outside.

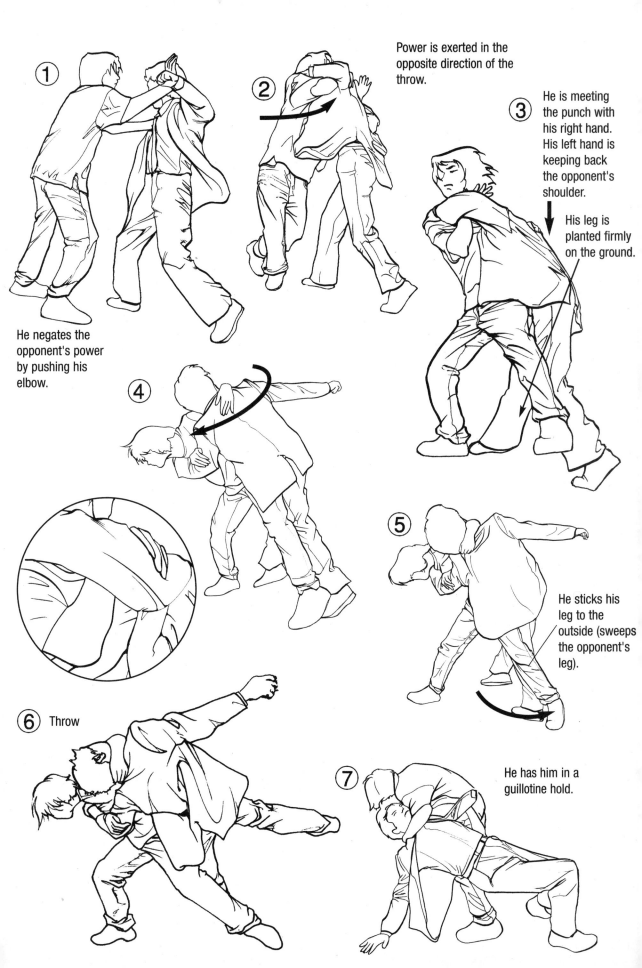

① He negates the opponent's power by pushing his elbow.

②

Power is exerted in the opposite direction of the throw.

③ He is meeting the punch with his right hand. His left hand is keeping back the opponent's shoulder.

His leg is planted firmly on the ground.

④

⑤ He sticks his leg to the outside (sweeps the opponent's leg).

⑥ Throw

⑦ He has him in a guillotine hold.

Grabbing the Collar

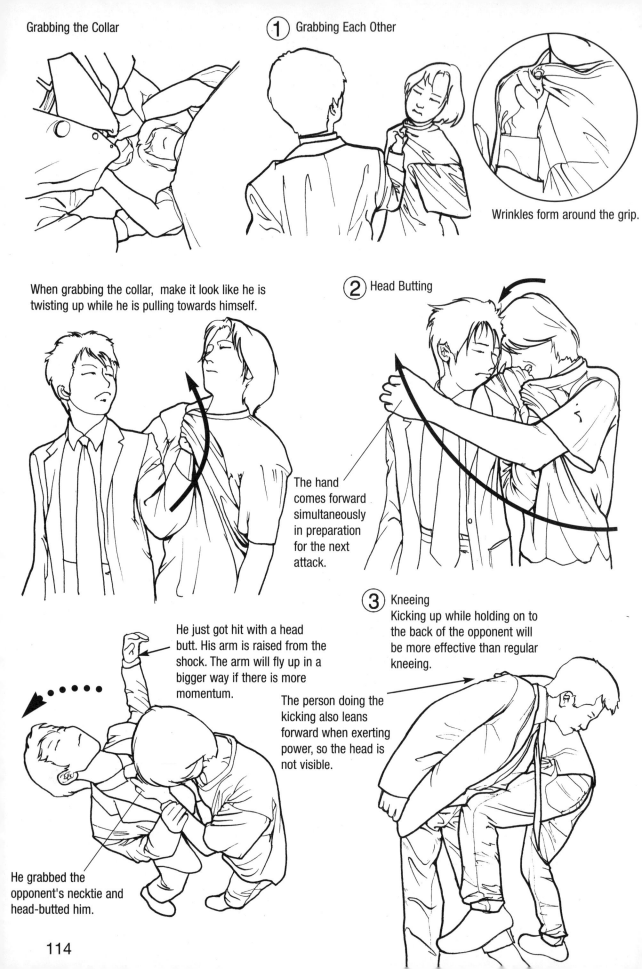

1 Grabbing Each Other

Wrinkles form around the grip.

When grabbing the collar, make it look like he is twisting up while he is pulling towards himself.

The hand comes forward simultaneously in preparation for the next attack.

2 Head Butting

3 Kneeing
Kicking up while holding on to the back of the opponent will be more effective than regular kneeing.

He just got hit with a head butt. His arm is raised from the shock. The arm will fly up in a bigger way if there is more momentum.

The person doing the kicking also leans forward when exerting power, so the head is not visible.

He grabbed the opponent's necktie and head-butted him.

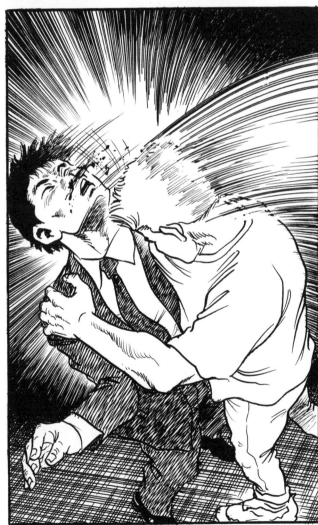

This scene was drawn using the collar grabbing and head butting on the opposite page. The third frame with a close-up of the protagonist is the only original frame. A powerful progression of pictures can easily be put together by insertion of a single cut.

Kicking and Punching

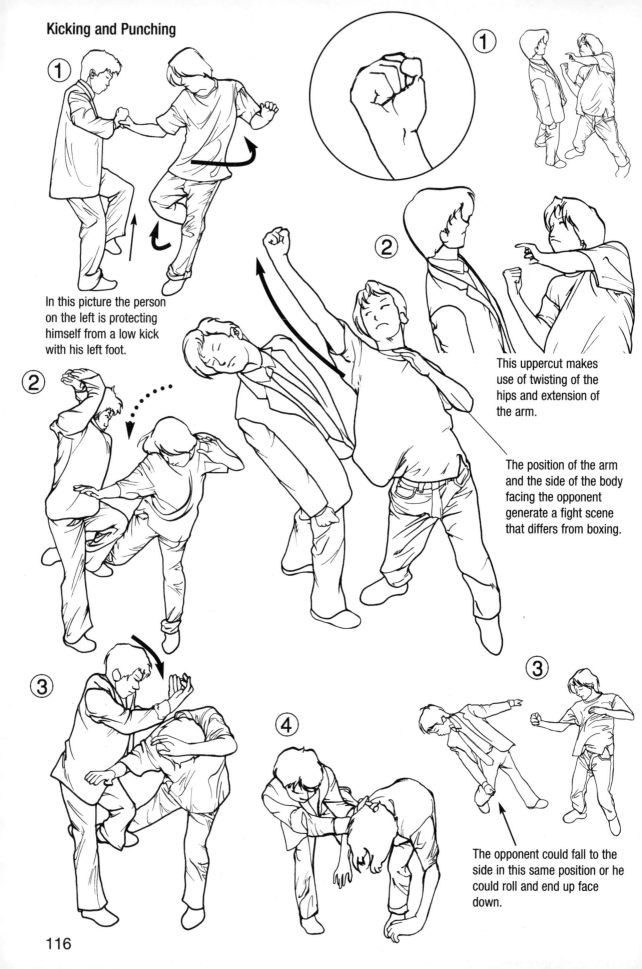

①

In this picture the person on the left is protecting himself from a low kick with his left foot.

②

③

④

①

②

This uppercut makes use of twisting of the hips and extension of the arm.

The position of the arm and the side of the body facing the opponent generate a fight scene that differs from boxing.

③

The opponent could fall to the side in this same position or he could roll and end up face down.

① If he swings his left hand without swinging from the hip, he will look girlish or amateurish.

He is swaying back to avoid a punch.

His hand is open, so we can tell it is going to be a palm-heel punch.

②

This is the instant of the impact after swinging as hard as he could.

The hem of the jacket flies way up when the trajectory is from the upper right to the lower left.

④

③

Note the direction the arm is traveling and the direction of the legs. This indicates twisting of the hips.

This is after he has hit his opponent with all his might. His arm bends as if wrapping around his stomach and his upper body is leaning forward.

He is swinging up his right knee using the power of the arm swinging down. He is hitting the lower abdomen or the bull's-eye.

⑤

⑥

You can also turn over the ankle and send the opponent flying with a kick to the abdomen.

He is swinging his arm in the opposite direction and his upper body is erect. The necktie streams and the hem of the jacket flutter in the direction of the movement.

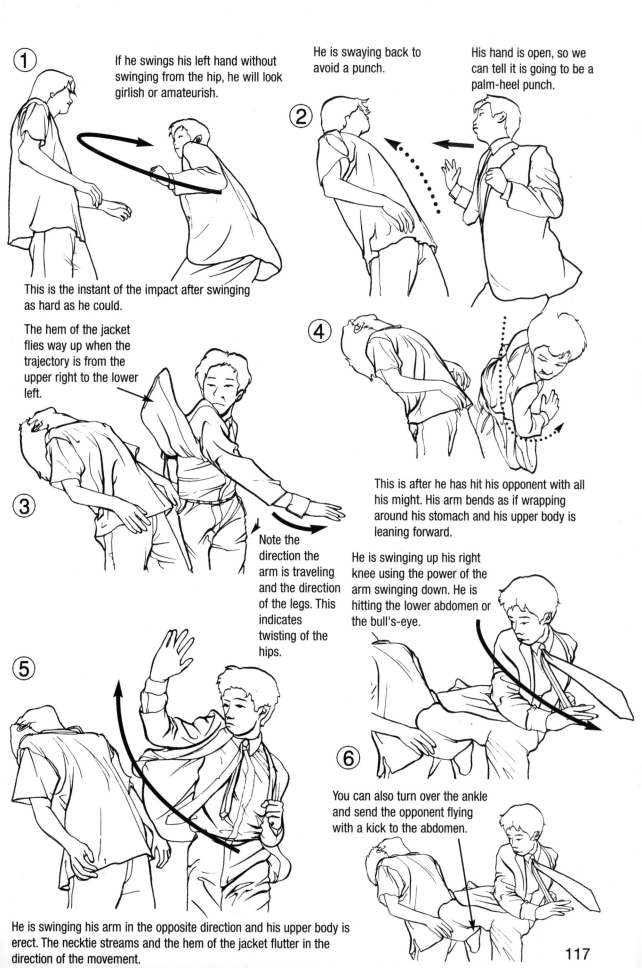

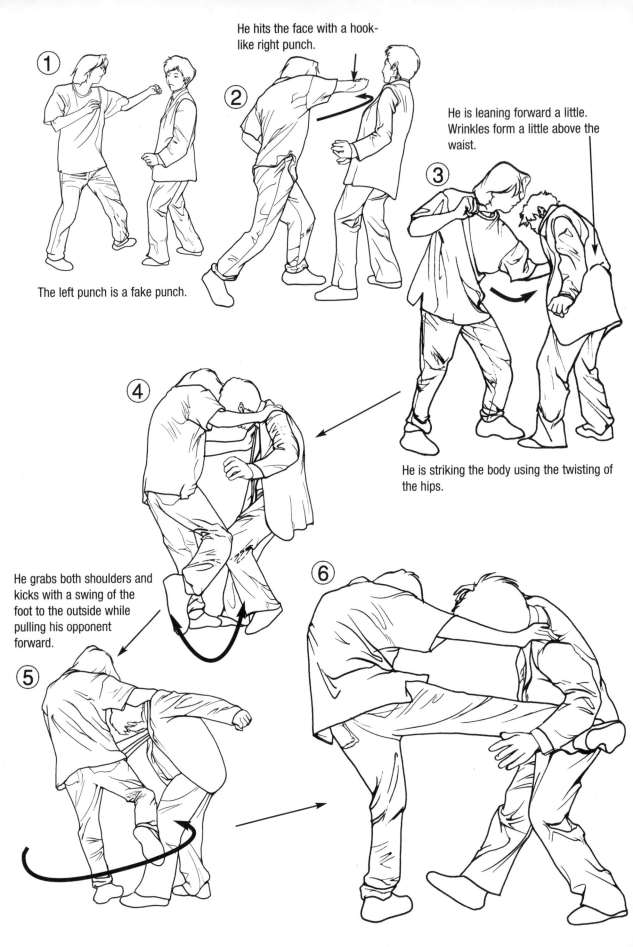

① The left punch is a fake punch.

He hits the face with a hook-like right punch.

② He is leaning forward a little. Wrinkles form a little above the waist.

③ He is striking the body using the twisting of the hips.

He grabs both shoulders and kicks with a swing of the foot to the outside while pulling his opponent forward.

④

⑤

⑥

Reverse Spinning Kick

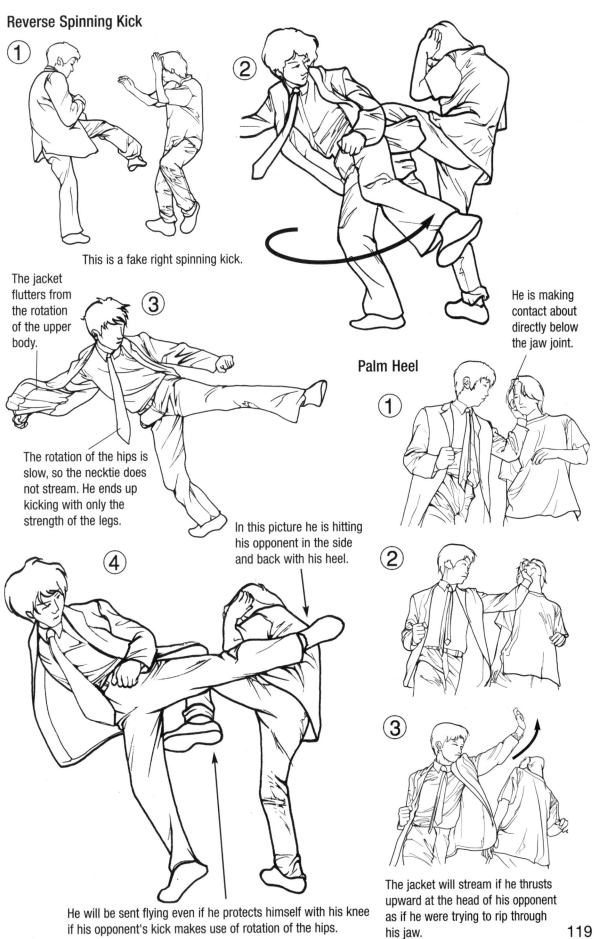

① This is a fake right spinning kick.

② He is making contact about directly below the jaw joint.

③ The jacket flutters from the rotation of the upper body.

The rotation of the hips is slow, so the necktie does not stream. He ends up kicking with only the strength of the legs.

In this picture he is hitting his opponent in the side and back with his heel.

④ He will be sent flying even if he protects himself with his knee if his opponent's kick makes use of rotation of the hips.

Palm Heel

①

②

③ The jacket will stream if he thrusts upward at the head of his opponent as if he were trying to rip through his jaw.

Uppercut

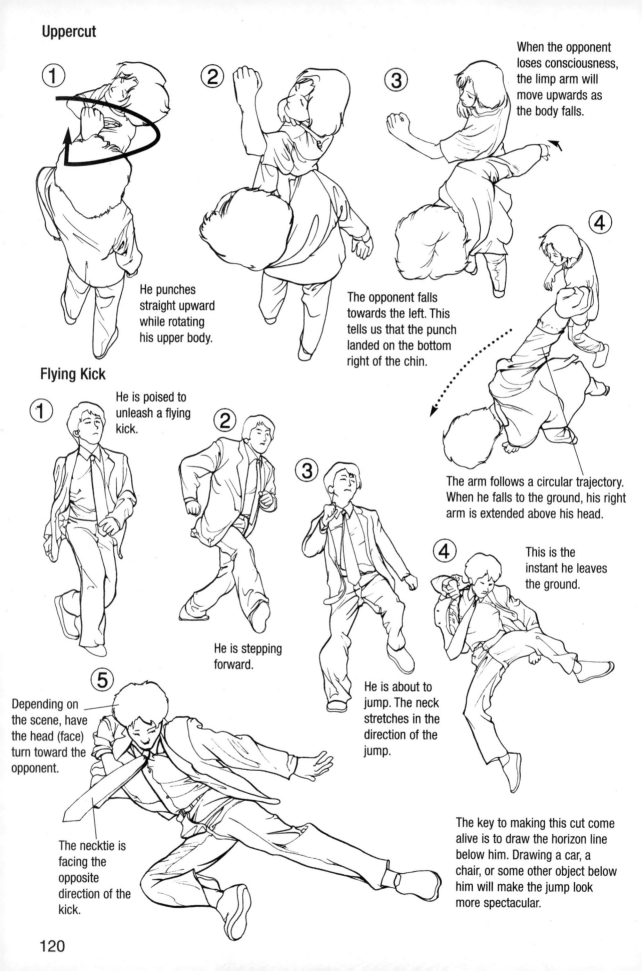

① He punches straight upward while rotating his upper body.

② The opponent falls towards the left. This tells us that the punch landed on the bottom right of the chin.

③ When the opponent loses consciousness, the limp arm will move upwards as the body falls.

④ The arm follows a circular trajectory. When he falls to the ground, his right arm is extended above his head.

Flying Kick

① He is poised to unleash a flying kick.

② He is stepping forward.

③ He is about to jump. The neck stretches in the direction of the jump.

④ This is the instant he leaves the ground.

⑤ Depending on the scene, have the head (face) turn toward the opponent.

The necktie is facing the opposite direction of the kick.

The key to making this cut come alive is to draw the horizon line below him. Drawing a car, a chair, or some other object below him will make the jump look more spectacular.

Left Punch

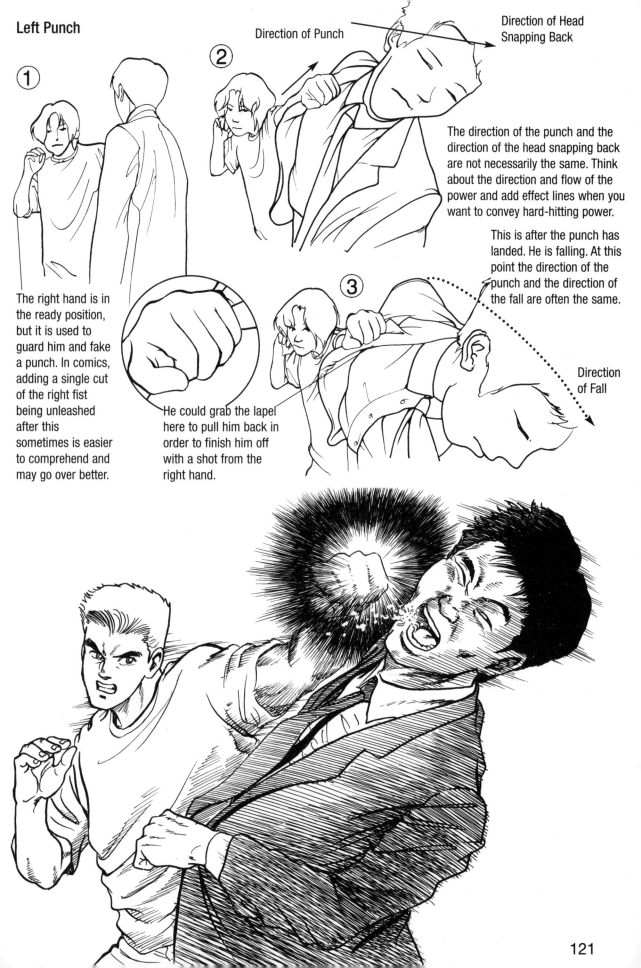

①

② **Direction of Punch** **Direction of Head Snapping Back**

The direction of the punch and the direction of the head snapping back are not necessarily the same. Think about the direction and flow of the power and add effect lines when you want to convey hard-hitting power.

This is after the punch has landed. He is falling. At this point the direction of the punch and the direction of the fall are often the same.

The right hand is in the ready position, but it is used to guard him and fake a punch. In comics, adding a single cut of the right fist being unleashed after this sometimes is easier to comprehend and may go over better.

③

He could grab the lapel here to pull him back in order to finish him off with a shot from the right hand.

Direction of Fall

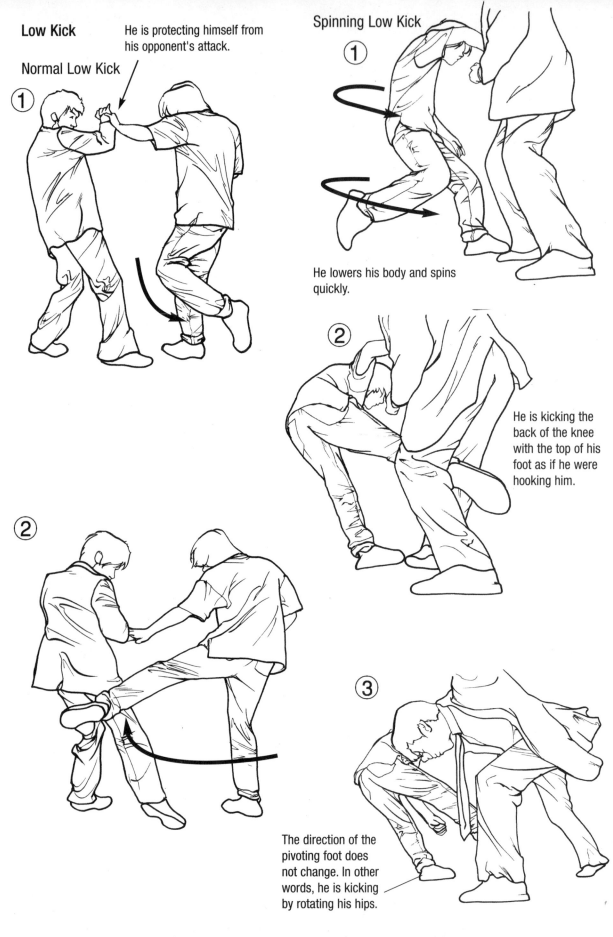

Low Kick

He is protecting himself from his opponent's attack.

Normal Low Kick

①

②

Spinning Low Kick

①

He lowers his body and spins quickly.

②

He is kicking the back of the knee with the top of his foot as if he were hooking him.

③

The direction of the pivoting foot does not change. In other words, he is kicking by rotating his hips.

Outside Version of Spinning Low Kick

① Note that there is distance between the two.

The person attacking lifts his leg just a little. Lifting it about this high will look like he is simply stepping forward.

② The legs of the opponent are completely defenseless, perhaps because he is preoccupied with things going on higher up.

Depict him stepping forward quickly. The toes point outward in preparation for spinning, but the position of his upper body is the same as before.

The kicking foot is already perpendicular and ready to unleash the kick immediately.

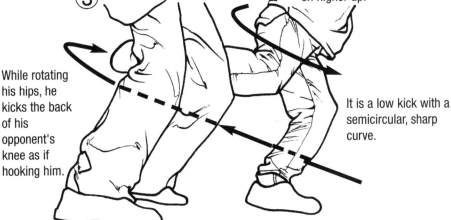

③ While rotating his hips, he kicks the back of his opponent's knee as if hooking him.

It is a low kick with a semicircular, sharp curve.

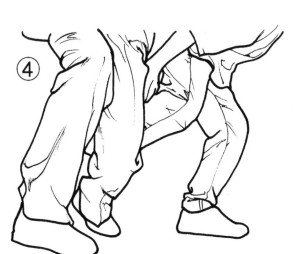

④ Merely pushing the back of the knee with the hand would cause the opponent to fall to his knee.

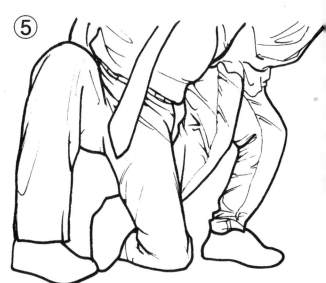

⑤ Stopping the action when the kick hits the back of the knee looks like this.

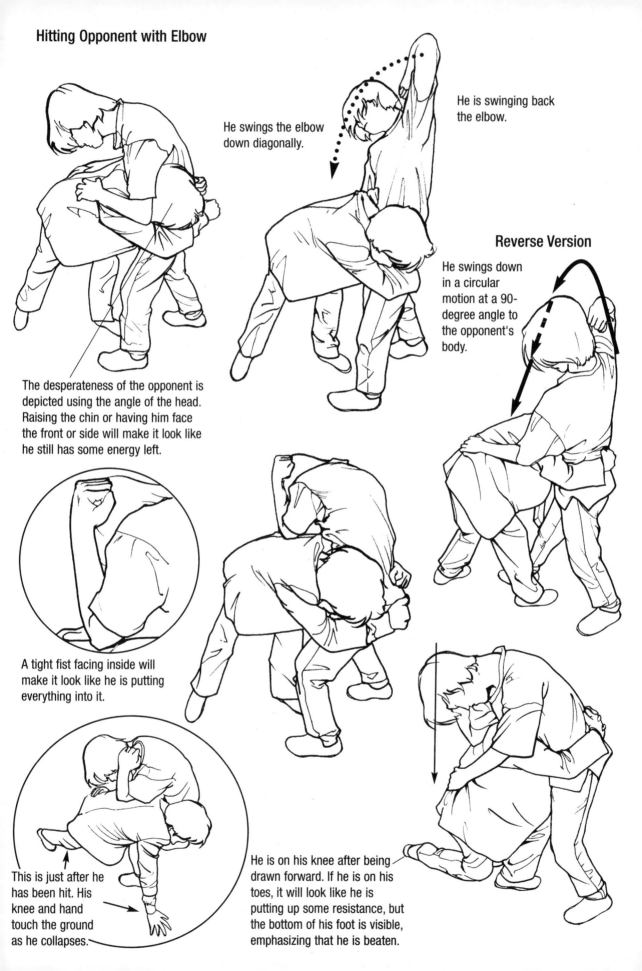

Hitting Opponent with Elbow

He swings the elbow down diagonally.

He is swinging back the elbow.

Reverse Version

He swings down in a circular motion at a 90-degree angle to the opponent's body.

The desperateness of the opponent is depicted using the angle of the head. Raising the chin or having him face the front or side will make it look like he still has some energy left.

A tight fist facing inside will make it look like he is putting everything into it.

This is just after he has been hit. His knee and hand touch the ground as he collapses.

He is on his knee after being drawn forward. If he is on his toes, it will look like he is putting up some resistance, but the bottom of his foot is visible, emphasizing that he is beaten.

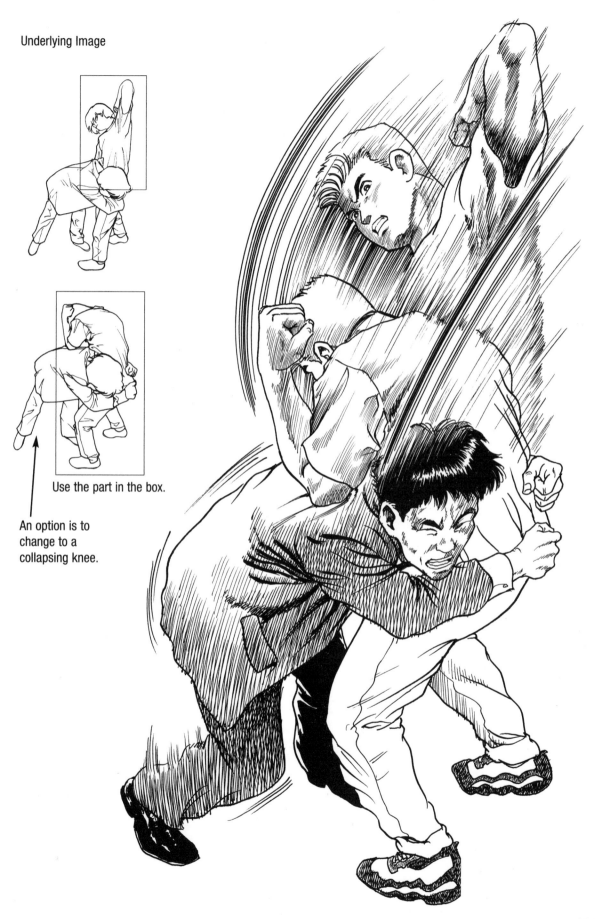

Use the part in the box.

An option is to
change to a
collapsing knee.

Kicking Poses: Middle Kick/Upper Kick

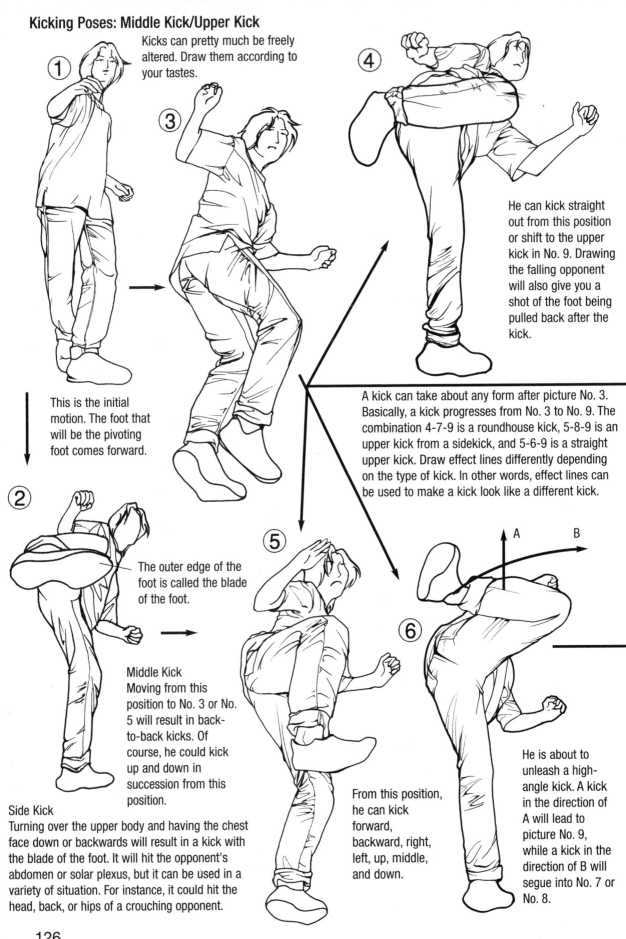

① Kicks can pretty much be freely altered. Draw them according to your tastes.

This is the initial motion. The foot that will be the pivoting foot comes forward.

③

②

The outer edge of the foot is called the blade of the foot.

Middle Kick
Moving from this position to No. 3 or No. 5 will result in back-to-back kicks. Of course, he could kick up and down in succession from this position.

Side Kick
Turning over the upper body and having the chest face down or backwards will result in a kick with the blade of the foot. It will hit the opponent's abdomen or solar plexus, but it can be used in a variety of situation. For instance, it could hit the head, back, or hips of a crouching opponent.

④ He can kick straight out from this position or shift to the upper kick in No. 9. Drawing the falling opponent will also give you a shot of the foot being pulled back after the kick.

A kick can take about any form after picture No. 3. Basically, a kick progresses from No. 3 to No. 9. The combination 4-7-9 is a roundhouse kick, 5-8-9 is an upper kick from a sidekick, and 5-6-9 is a straight upper kick. Draw effect lines differently depending on the type of kick. In other words, effect lines can be used to make a kick look like a different kick.

⑤

From this position, he can kick forward, backward, right, left, up, middle, and down.

⑥

A B

He is about to unleash a high-angle kick. A kick in the direction of A will lead to picture No. 9, while a kick in the direction of B will segue into No. 7 or No. 8.

126

⑦ This is a large roundhouse kick from the side. You should use this when you want a kick to be a heavy kick with maximum power and speed.

⑨ This is an upper kick that is directed straight up. The sole of the shoe hits the side of the face or chin diagonally from below. The entire sole of the foot could be shown or the heel could be sticking out. With a stretch he could also wrap the top of his foot around the opponent's neck and take him down.

Both arms are hanging limp, so it looks like his power is concentrated in his legs. This and the fact that the sole of the foot cannot be seen make the kick look heavier.

⑧ This kick is more stable than No. 7. It is suited for a slap to the face with the foot or a scene just before a kick lands. You could also look at it from a different perspective and use it as a right-to-left roundhouse kick or high-angle backward kick.

The leg is fully extended, so he will fall down if the right leg is not used to stop the fall.

⑩ This is after the kick. It is effective used together with the opponent sinking to the ground or flying through the air.

His entire weight is on the front sole of the foot.

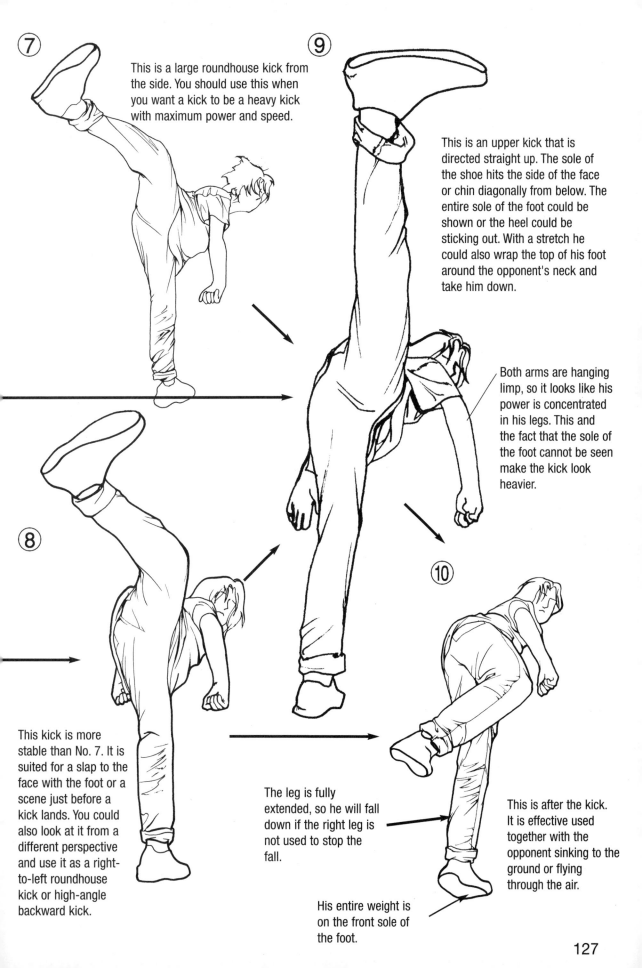

Front Kick

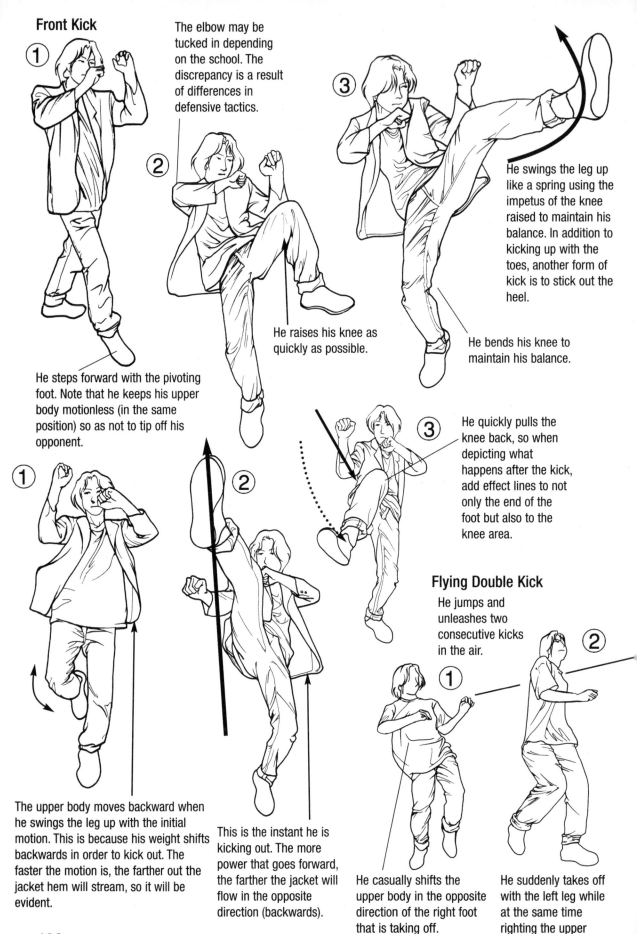

①

The elbow may be tucked in depending on the school. The discrepancy is a result of differences in defensive tactics.

②

He steps forward with the pivoting foot. Note that he keeps his upper body motionless (in the same position) so as not to tip off his opponent.

He raises his knee as quickly as possible.

③

He swings the leg up like a spring using the impetus of the knee raised to maintain his balance. In addition to kicking up with the toes, another form of kick is to stick out the heel.

He bends his knee to maintain his balance.

①

②

③

He quickly pulls the knee back, so when depicting what happens after the kick, add effect lines to not only the end of the foot but also to the knee area.

The upper body moves backward when he swings the leg up with the initial motion. This is because his weight shifts backwards in order to kick out. The faster the motion is, the farther out the jacket hem will stream, so it will be evident.

This is the instant he is kicking out. The more power that goes forward, the farther the jacket will flow in the opposite direction (backwards).

Flying Double Kick

He jumps and unleashes two consecutive kicks in the air.

①

②

He casually shifts the upper body in the opposite direction of the right foot that is taking off.

He suddenly takes off with the left leg while at the same time righting the upper body.

Side Kick Variation

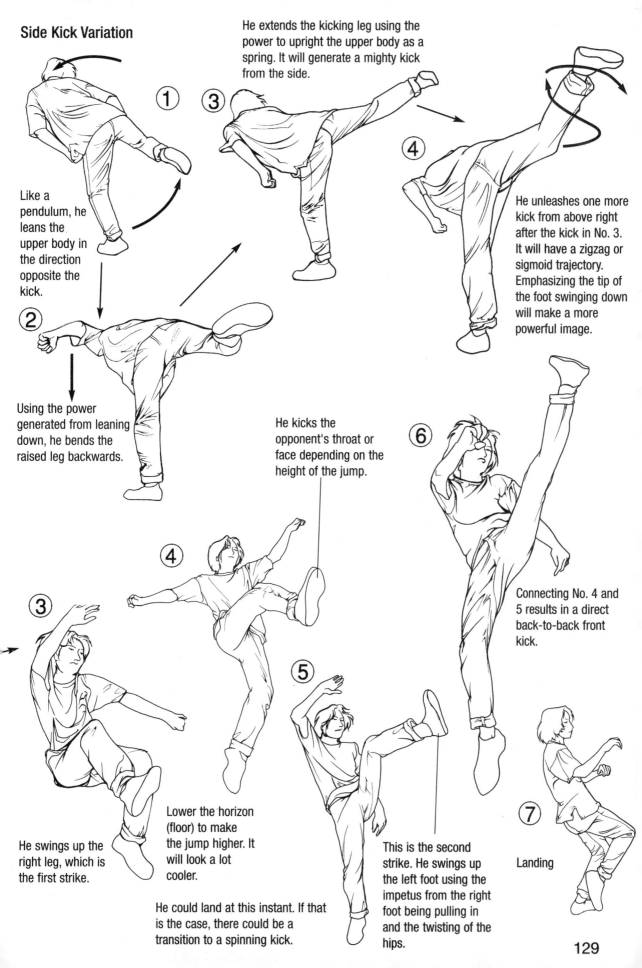

① Like a pendulum, he leans the upper body in the direction opposite the kick.

② Using the power generated from leaning down, he bends the raised leg backwards.

③ He extends the kicking leg using the power to upright the upper body as a spring. It will generate a mighty kick from the side.

④ He unleashes one more kick from above right after the kick in No. 3. It will have a zigzag or sigmoid trajectory. Emphasizing the tip of the foot swinging down will make a more powerful image.

He kicks the opponent's throat or face depending on the height of the jump.

③ He swings up the right leg, which is the first strike.

④ Lower the horizon (floor) to make the jump higher. It will look a lot cooler.

He could land at this instant. If that is the case, there could be a transition to a spinning kick.

⑤ This is the second strike. He swings up the left foot using the impetus from the right foot being pulling in and the twisting of the hips.

⑥ Connecting No. 4 and 5 results in a direct back-to-back front kick.

⑦ Landing

129

Spinning Kick 1

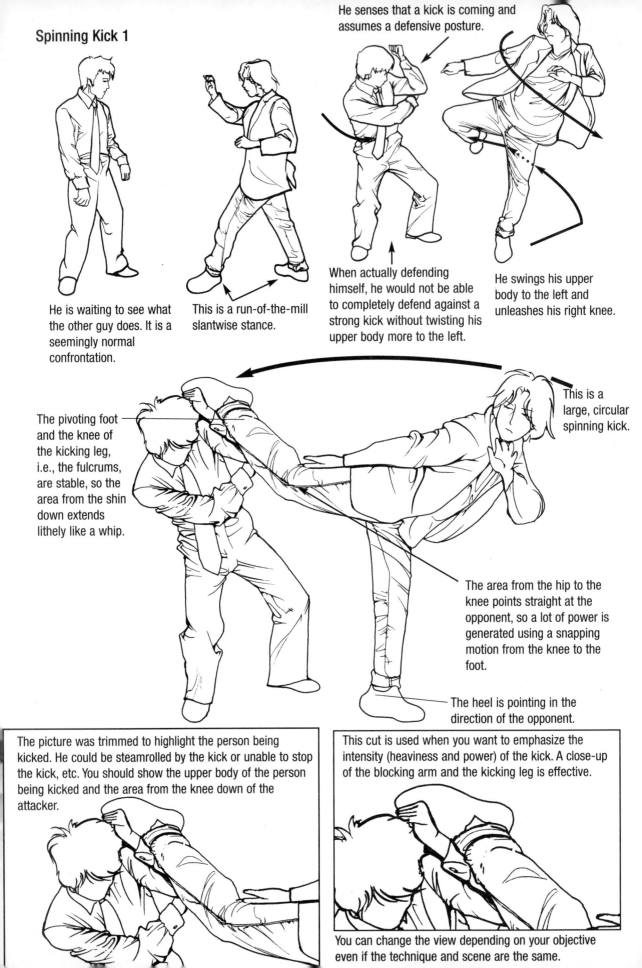

He is waiting to see what the other guy does. It is a seemingly normal confrontation.

This is a run-of-the-mill slantwise stance.

He senses that a kick is coming and assumes a defensive posture.

When actually defending himself, he would not be able to completely defend against a strong kick without twisting his upper body more to the left.

He swings his upper body to the left and unleashes his right knee.

This is a large, circular spinning kick.

The pivoting foot and the knee of the kicking leg, i.e., the fulcrums, are stable, so the area from the shin down extends lithely like a whip.

The area from the hip to the knee points straight at the opponent, so a lot of power is generated using a snapping motion from the knee to the foot.

The heel is pointing in the direction of the opponent.

The picture was trimmed to highlight the person being kicked. He could be steamrolled by the kick or unable to stop the kick, etc. You should show the upper body of the person being kicked and the area from the knee down of the attacker.

This cut is used when you want to emphasize the intensity (heaviness and power) of the kick. A close-up of the blocking arm and the kicking leg is effective.

You can change the view depending on your objective even if the technique and scene are the same.

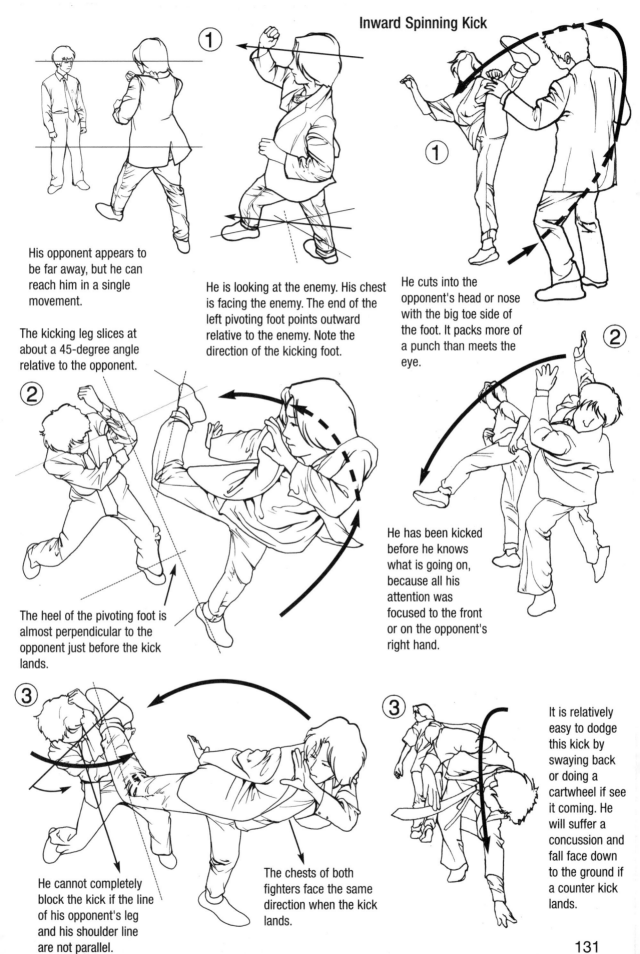

His opponent appears to be far away, but he can reach him in a single movement.

The kicking leg slices at about a 45-degree angle relative to the opponent.

He is looking at the enemy. His chest is facing the enemy. The end of the left pivoting foot points outward relative to the enemy. Note the direction of the kicking foot.

He cuts into the opponent's head or nose with the big toe side of the foot. It packs more of a punch than meets the eye.

The heel of the pivoting foot is almost perpendicular to the opponent just before the kick lands.

He has been kicked before he knows what is going on, because all his attention was focused to the front or on the opponent's right hand.

He cannot completely block the kick if the line of his opponent's leg and his shoulder line are not parallel.

The chests of both fighters face the same direction when the kick lands.

It is relatively easy to dodge this kick by swaying back or doing a cartwheel if see it coming. He will suffer a concussion and fall face down to the ground if a counter kick lands.

Spinning Kick 2

① The hem of the jacket streams to the left. This indicates that he is twisting his body strongly in the opposite direction.

A spinning kick from a high position follows a sharp rainbow curve.

The defender has to move in the direction of the arrow in order to sustain the kick.

②

His hips are backing away, so we know he is scared and an inferior fighter. You can depict a competent fighter by having him lean slightly forward.

His fist hits his head as he is unable to sustain the force of the kick. He was unable to block the kick.

③ Instantaneous Block

④

The kicker does not lose his balance. He can subsequently shift to any other attack without delay.

From a presentation standpoint this is a slow motion shot.

His blocking fails and he is knocked over.

His head is facing down, so there is a sense of defeat in the air.

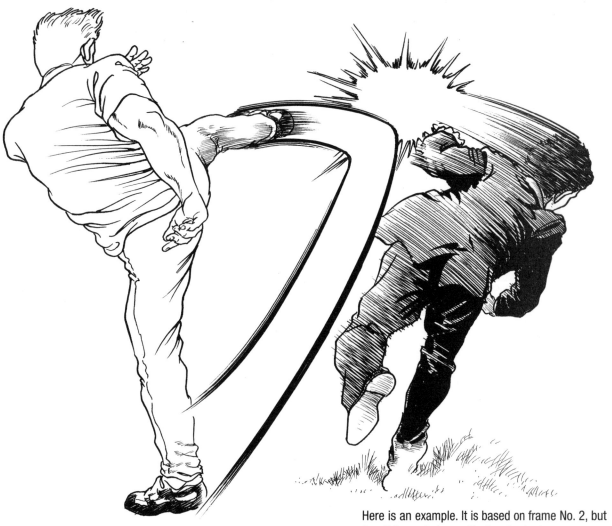

Here is an example. It is based on frame No. 2, but the distance between the two is shorter.

Spinning Kick from the Side

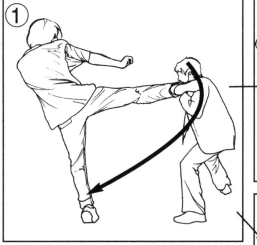

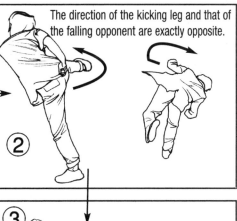

The direction of the kicking leg and that of the falling opponent are exactly opposite.

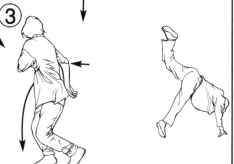

He kicks the face or the side of the head without giving his opponent a chance to block it. The action progresses from No. 1 to No. 2 and then No. 3, but it could go directly from No. 1 to No. 3.

The kicking leg is set down smoothly.

The knee is bent after kicking and he does not take his eyes off his opponent. This makes it look like he is used to fighting and able to take the next action at anytime.

133

Spinning Kick 3

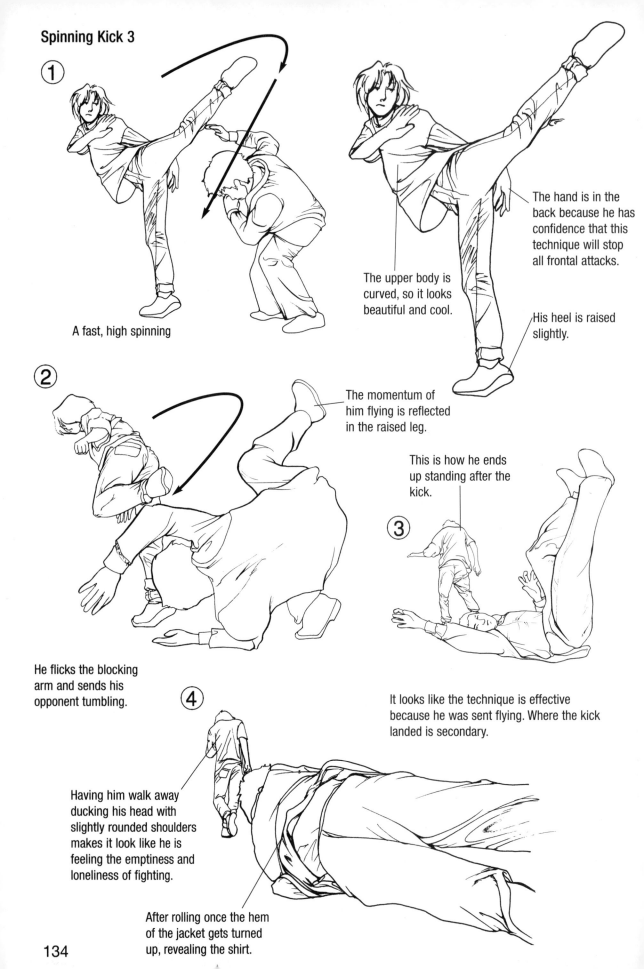

① A fast, high spinning

The hand is in the back because he has confidence that this technique will stop all frontal attacks.

The upper body is curved, so it looks beautiful and cool.

His heel is raised slightly.

② The momentum of him flying is reflected in the raised leg.

He flicks the blocking arm and sends his opponent tumbling.

This is how he ends up standing after the kick.

③

It looks like the technique is effective because he was sent flying. Where the kick landed is secondary.

④

Having him walk away ducking his head with slightly rounded shoulders makes it look like he is feeling the emptiness and loneliness of fighting.

After rolling once the hem of the jacket gets turned up, revealing the shirt.

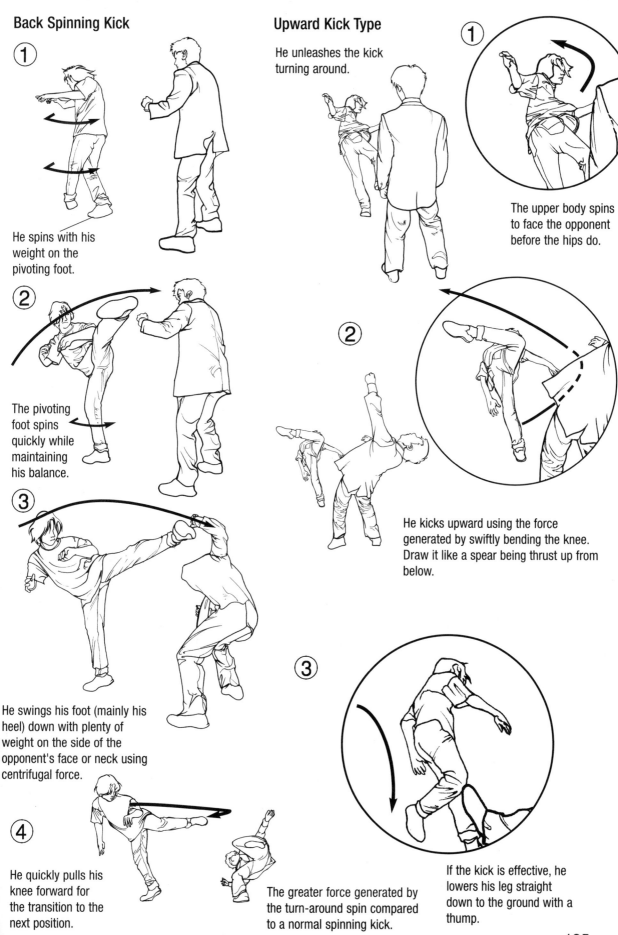

Back Spinning Kick

① He spins with his weight on the pivoting foot.

② The pivoting foot spins quickly while maintaining his balance.

③ He swings his foot (mainly his heel) down with plenty of weight on the side of the opponent's face or neck using centrifugal force.

④ He quickly pulls his knee forward for the transition to the next position.

The greater force generated by the turn-around spin compared to a normal spinning kick.

Upward Kick Type

He unleashes the kick turning around.

① The upper body spins to face the opponent before the hips do.

② He kicks upward using the force generated by swiftly bending the knee. Draw it like a spear being thrust up from below.

③ If the kick is effective, he lowers his leg straight down to the ground with a thump.

Side Kick

This kick is used for a charging opponent.

① ②

He swings the leg up by swinging the upper body backwards.

② He lowers the upper body when kicking.

The kick landed below the right side of the face, so he is facing the other direction.

Kicking Opponent Over

①

A strong kick will give the opponent a concussion. His knees will buckle under him and he will fall.

②

He falls over. His back hits the floor. His legs fly up from the force of the kick.

③

③

What to do when the opponent has a weapon.

①

②

This kick can only be used when the person has the confidence and ability to kick faster than his opponent can swing the sword.

The opponent will fall directly backwards when hit with a powerful kick from the front.

He will roll with inertia when the force of the kick is strong.

Downward Spinning Kick

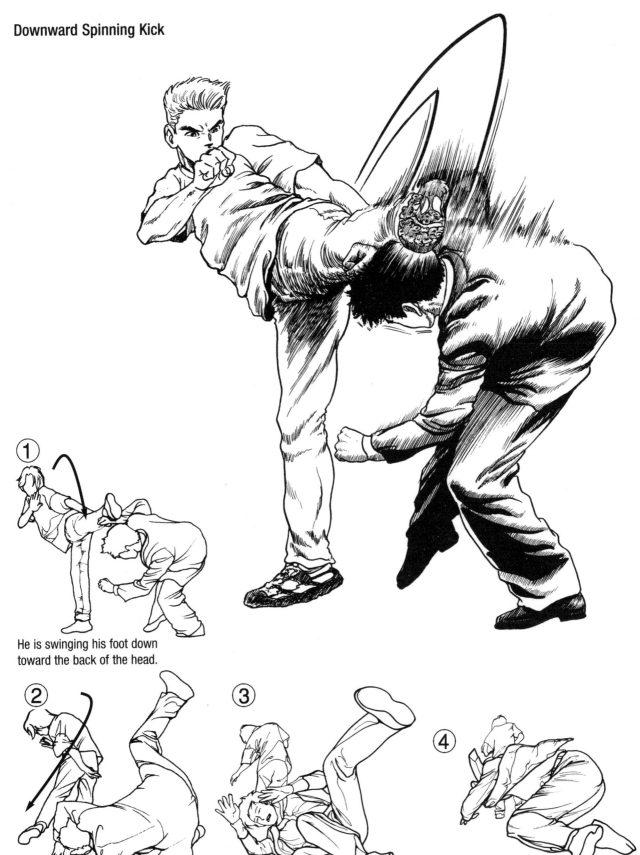

① He is swinging his foot down toward the back of the head.

② The keeps on moving along the same course.

③ His legs fly up from the force of the kick to the head and he gains momentum independently of his own will.

④ He rolls once and stops. The turned up necktie and jacket hem tell of the force.

Using Scene with Kick and Opponent Succumbing

Original Illustration

The composition was determined based on the above cut. The person succumbing was used after inverting the image.

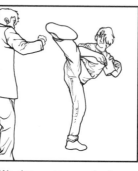

We drew upon a spinning kick for the kicking pose.

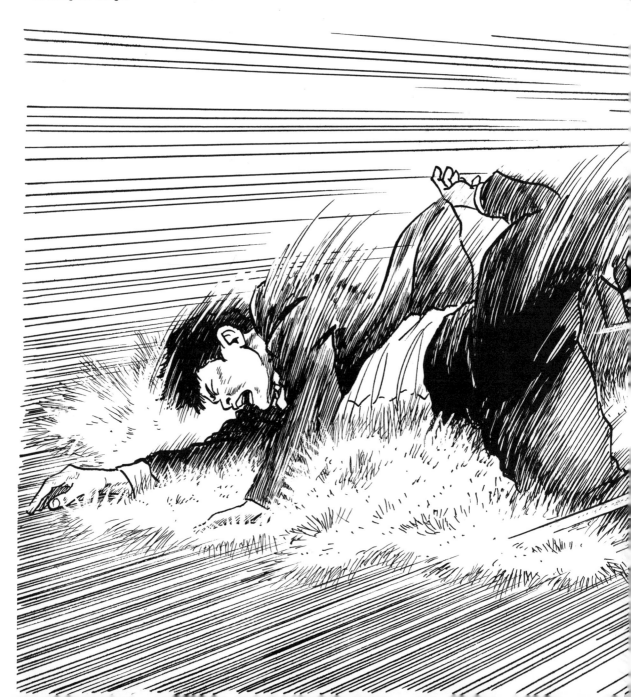

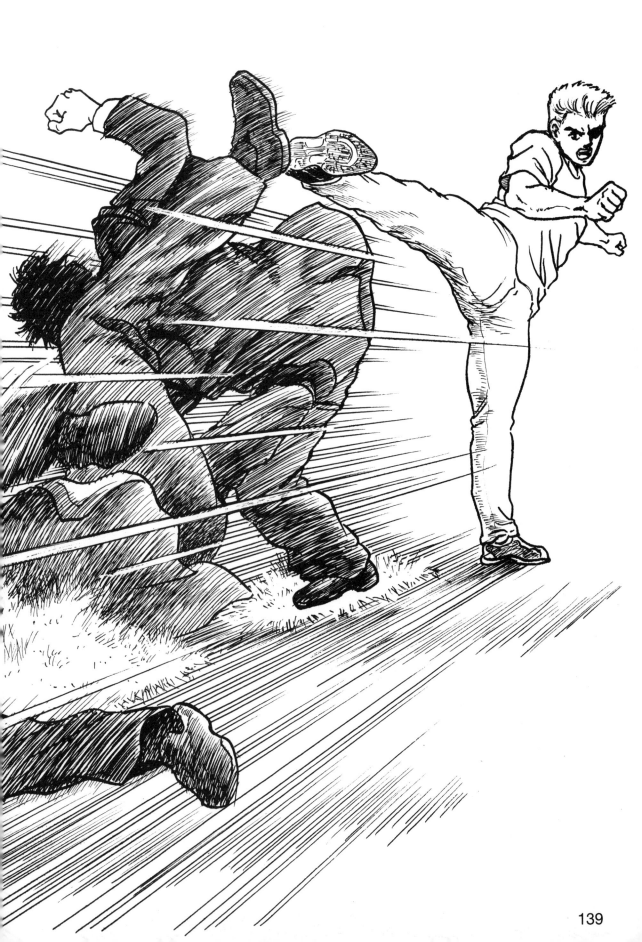

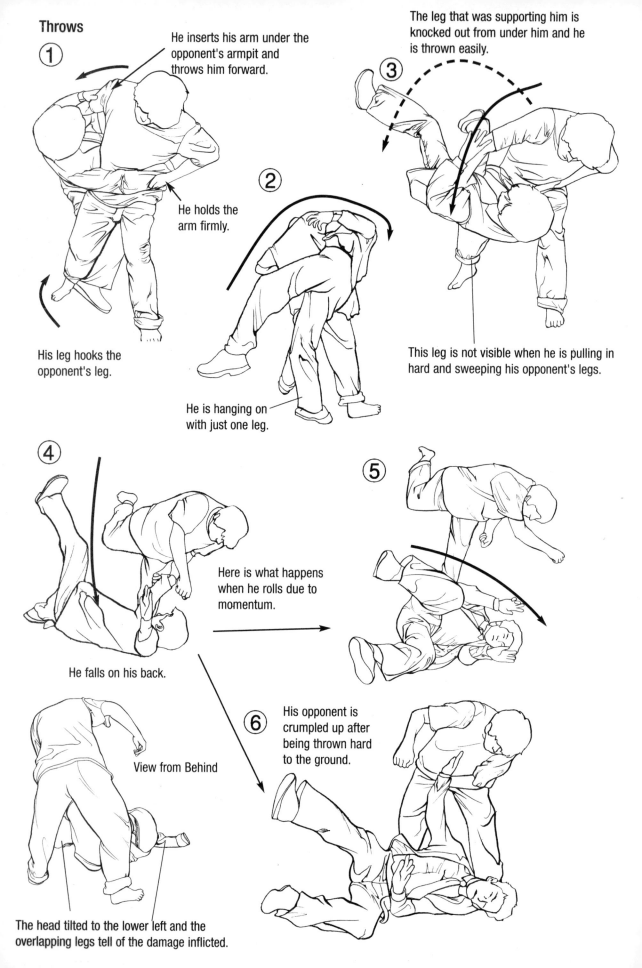

Throws

① He inserts his arm under the opponent's armpit and throws him forward.

He holds the arm firmly.

His leg hooks the opponent's leg.

② He is hanging on with just one leg.

③ The leg that was supporting him is knocked out from under him and he is thrown easily.

This leg is not visible when he is pulling in hard and sweeping his opponent's legs.

④ He falls on his back.

Here is what happens when he rolls due to momentum.

⑤

⑥ His opponent is crumpled up after being thrown hard to the ground.

View from Behind

The head tilted to the lower left and the overlapping legs tell of the damage inflicted.

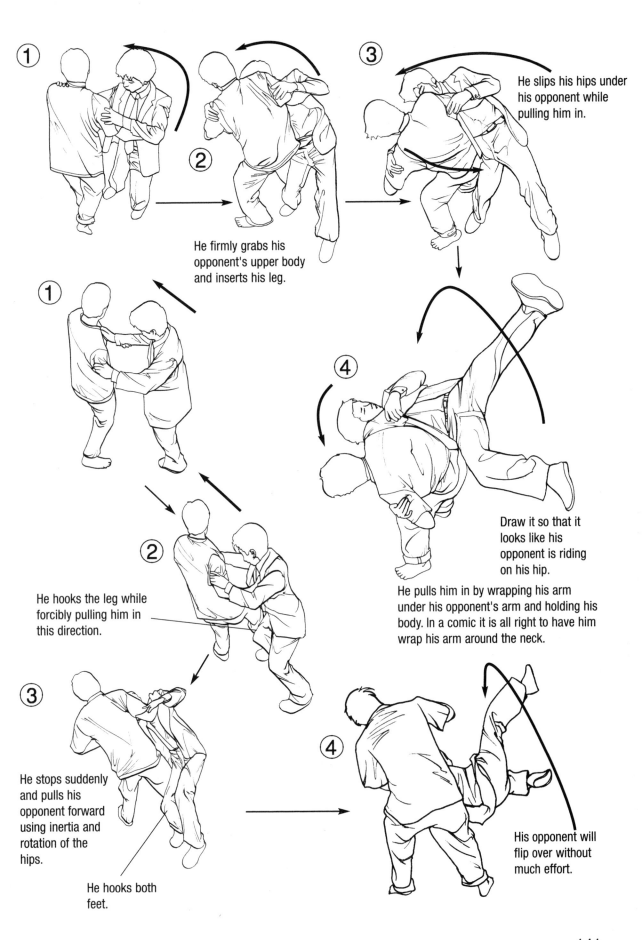

① ②

He firmly grabs his opponent's upper body and inserts his leg.

③ He slips his hips under his opponent while pulling him in.

④ Draw it so that it looks like his opponent is riding on his hip.

He pulls him in by wrapping his arm under his opponent's arm and holding his body. In a comic it is all right to have him wrap his arm around the neck.

①

② He hooks the leg while forcibly pulling him in this direction.

③ He stops suddenly and pulls his opponent forward using inertia and rotation of the hips.

He hooks both feet.

④ His opponent will flip over without much effort.

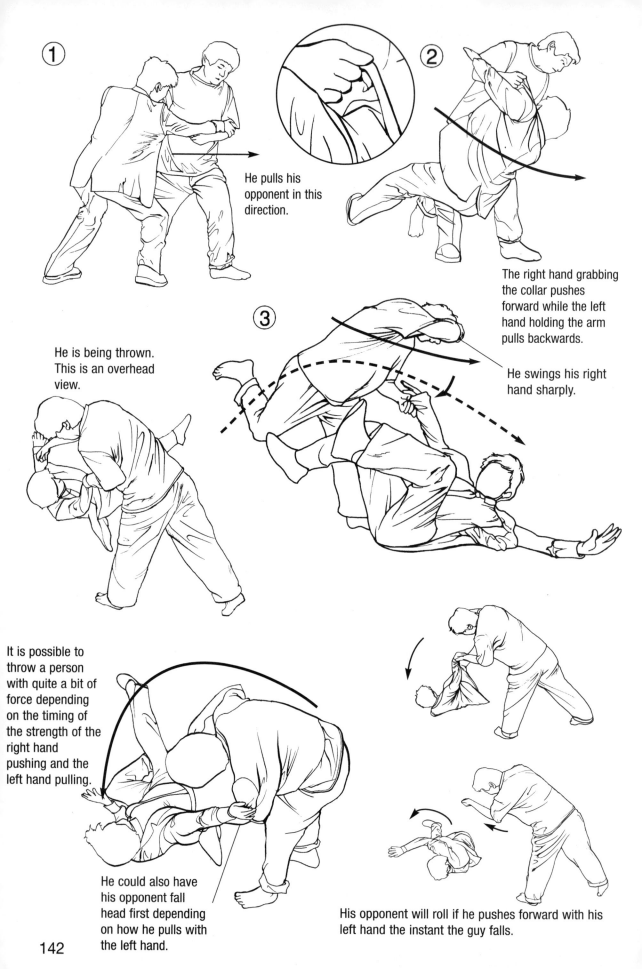

① He pulls his opponent in this direction.

② The right hand grabbing the collar pushes forward while the left hand holding the arm pulls backwards.

He swings his right hand sharply.

He is being thrown. This is an overhead view.

③

It is possible to throw a person with quite a bit of force depending on the timing of the strength of the right hand pushing and the left hand pulling.

He could also have his opponent fall head first depending on how he pulls with the left hand.

His opponent will roll if he pushes forward with his left hand the instant the guy falls.

Techniques for Increasing Impact of Throwing Scenes

Not Allowing Opponent to Get Set

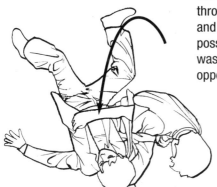

Draw the arms and legs bent in a scene of a person who has been thrown. It depends on the characters and the parameters, but it is possible to make it look like a throw was so fast and powerful that the opponent could not even get set.

Bringing the arm out to the side or having the palm of the hand face down will make it look like he was able to get set. Having the palm of the hand face up or drawing the elbow under the body will bring out the intensity of the throw and make it look painful.

Beware of Direction of Effect Lines

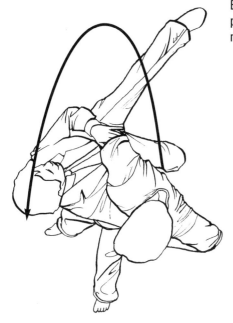

Effect lines are normally drawn parallel with movement, but they do not always have to be curved lines.

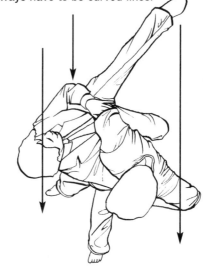

Straight lines can be used for shots from above and when the opponent is dropped straight down.

Drawing Throws Upside Down

Some throws can be made to look like different throws by simply turning them upside down.

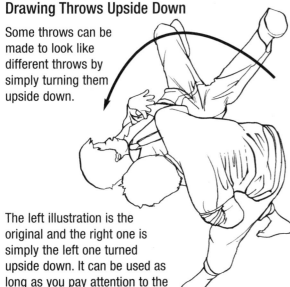

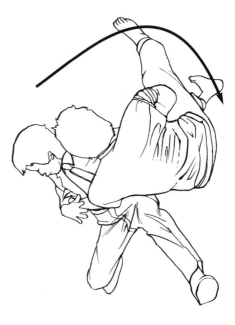

The left illustration is the original and the right one is simply the left one turned upside down. It can be used as long as you pay attention to the direction of effect lines and the direction clothing streams.

Various Poses of Person Succumbing

In battle scenes, it is important for the person succumbing to look like they are succumbing. Go overboard when drawing. Doing that will better highlight the strength of the attacker.

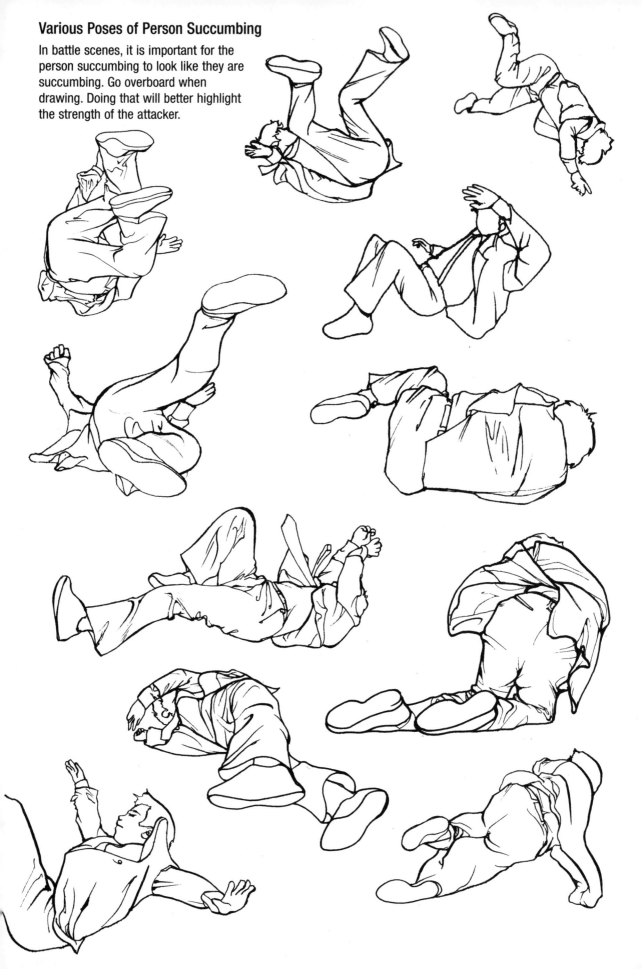

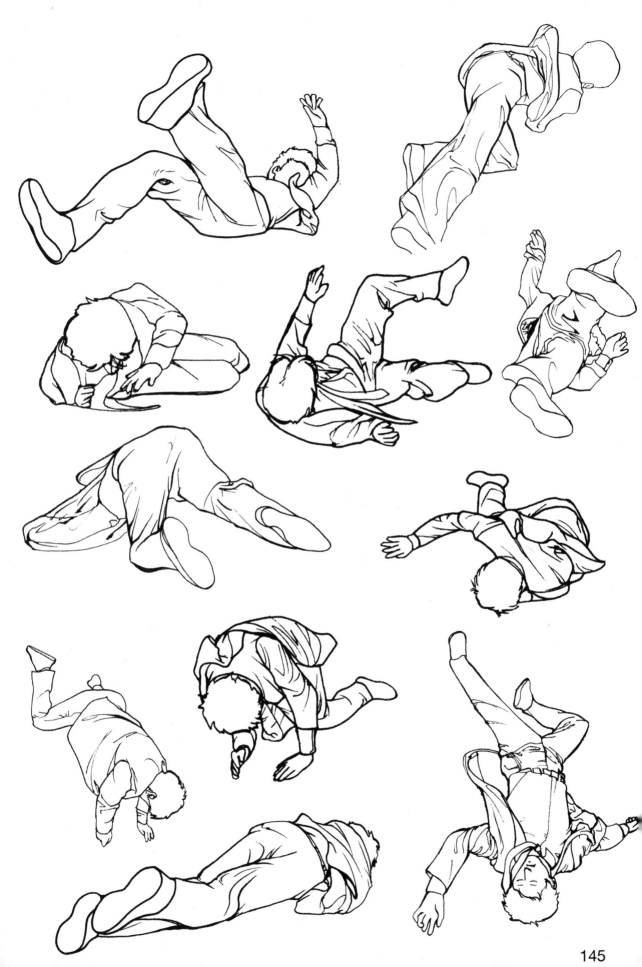

Drawing Person Succumbing with a Back Ground

Street battles are meaningless without a background. Use of various backgrounds and situations can bring poses of a person succumbing to life.

This is a person who has been thrown to the ground.

He was kicked with a straight leg.

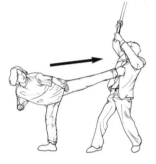

He was sent flying with a spinning kick.

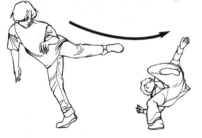

He is being thrown down.

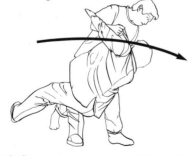

It is not always necessary to add the trajectory of movement in the form of effect lines. Depending on the frame and your intentions, effect lines may give the picture a stronger impact and make it easier to understand. Think of directions when drawing.

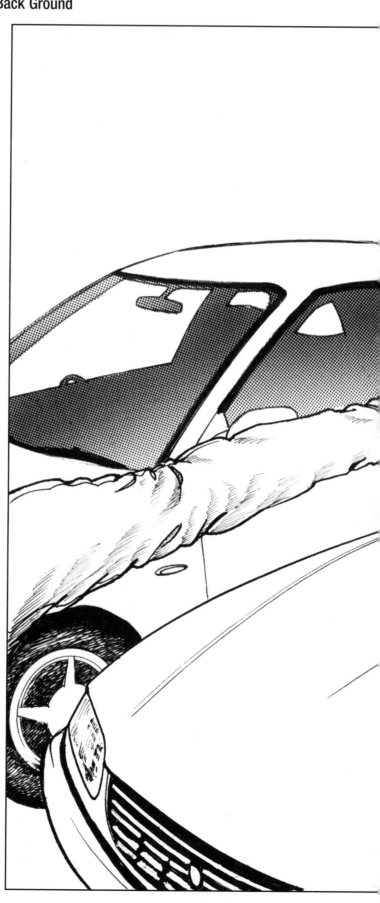

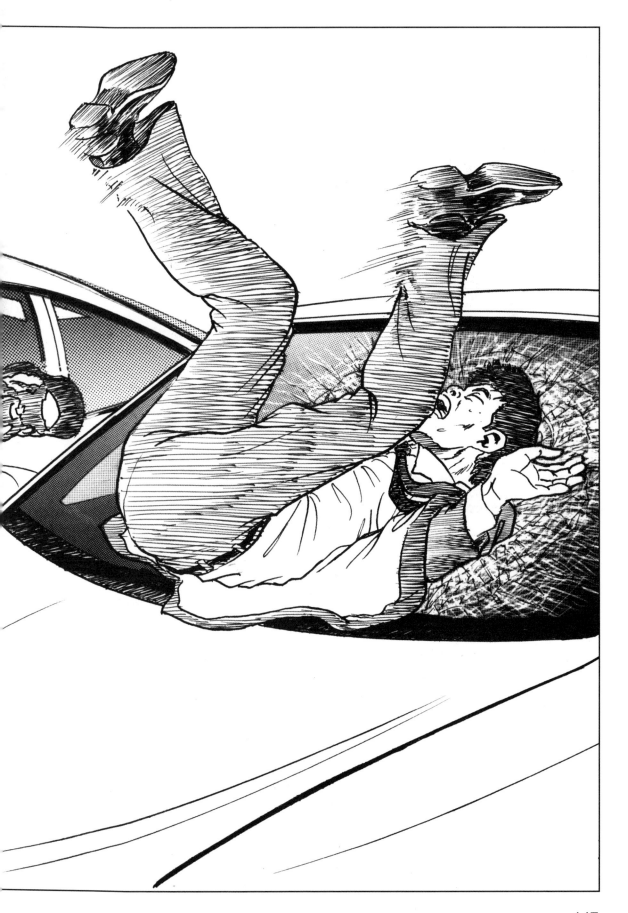

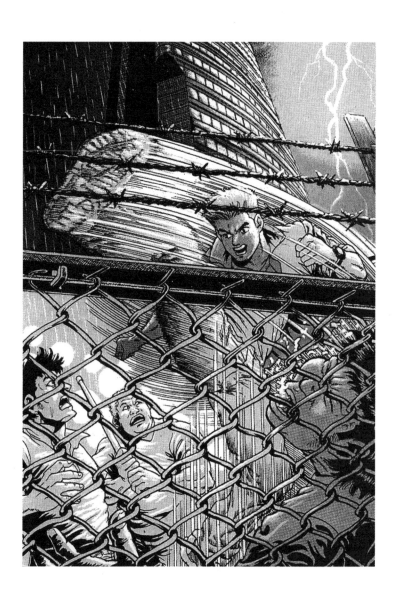